Artist's
Photo Reference
BOATS & NAUTICAL SCENES

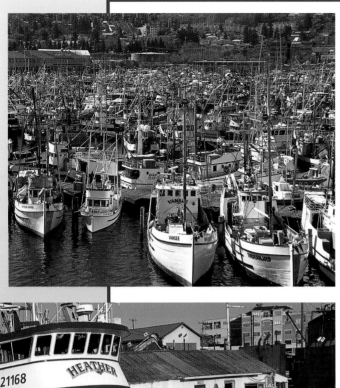

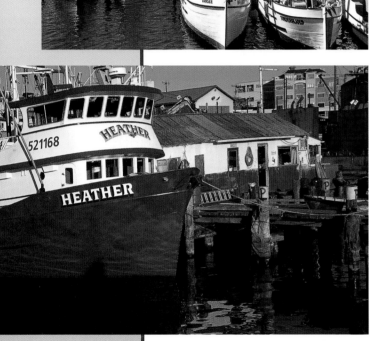

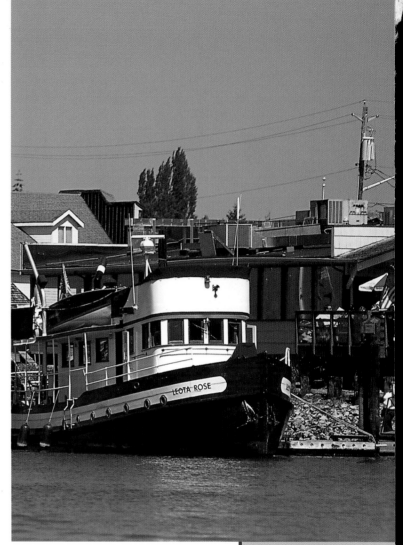

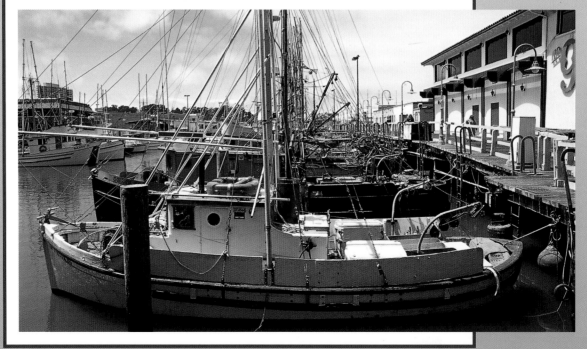

Artist's
Photo Reference
BOATS & NAUTICAL SCENES

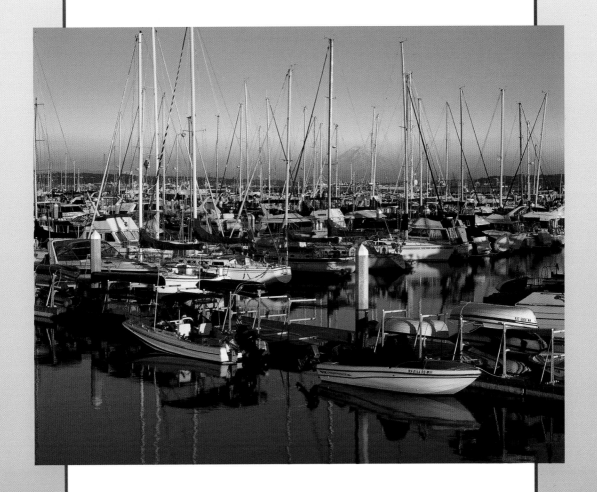

GARY GREENE

NORTH LIGHT BOOKS

Cincinnati, Ohio

www.artistsnetwork.com

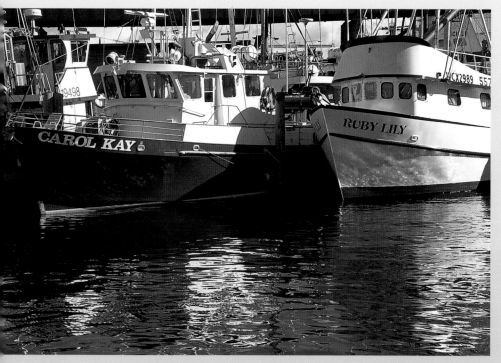

Other fine North Light Books are available from your local bookstore, art supply store or direct from the publisher.

07 06 05 04 03 5 4 3 2 1

Library of Congress Cataloging-in-Publication Data

Greene, Gary, 1942-
Artist's photo reference : Boats and nautical scenes / Gary Greene—1st ed.
 p. cm.
ISBN 1-58180-278-1 (pob: alk. paper)
1. Photography of ships. 2. Marine photography. 3. Ships in art. 4. Marine painting. 5. Painting from photographs. I. Title.

TR670.5.G74 2003
704.9'496238'2—dc21 2002043126
 CIP

Edited by Maria Tuttle
Designed by Kelly Songhen
Production coordinated by Mark Griffin

About the Author

In addition to being an accomplished professional photographer for over twenty years, Gary Greene is a talented fine artist, graphic designer, illustrator, author and instructor. Specializing in outdoor photography, Gary's photographs have been published by the National Geographic Society, Hallmark, Quest, the Environmental Protection Agency (EPA), Hertz, the Automobile Association of America (AAA), *Petersen's Photographic* magazine, *Popular Photography* and *Northwest Travel*. Gary has worked in a number of fine art mediums, including acrylic, airbrush, colored pencil and ink.

In addition to *Artist's Photo Reference: Boats and Nautical Scenes*, Gary is the author of *Artist's Photo reference: Buildings & Barns*, *Artist's Photo Reference: Landscapes*, *Artist's Photo Reference: Flowers*, *Creating Texture in Colored Pencil*, *Creating Radiant Flowers in Colored Pencil* and *Painting with Water-Soluble Colored Pencils*, all published by North Light Books. Gary's colored pencil paintings and his photographs have won numerous national and international awards. He has conducted workshops, demonstrations and lectures on photography and colored pencil since 1985.

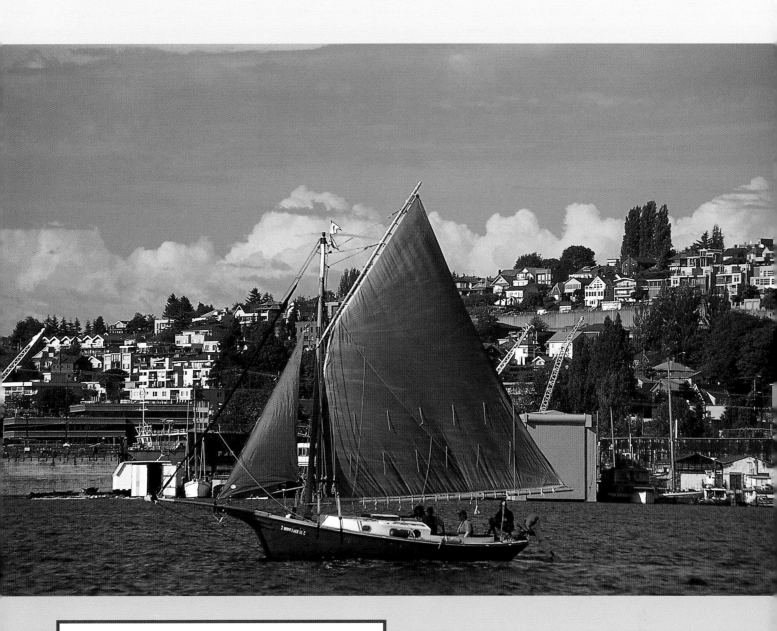

Metric Conversion Chart

to convert	to	multiply by
Inches	Centimeters	2.54
Centimeters	Inches	0.4
Feet	Centimeters	30.5
Centimeters	Feet	0.03
Yards	Meters	0.9
Meters	Yards	1.1
Sq. Inches	Sq. Centimeters	6.45
Sq. Centimeters	Sq. Inches	0.16
Sq. Feet	Sq. Meters	0.09
Sq. Meters	Sq. Feet	10.8
Sq. Yards	Sq. Meters	0.8
Sq. Meters	Sq. Yards	1.2
Pounds	Kilograms	0.45
Kilograms	Pounds	2.2
Ounces	Grams	28.3
Grams	Ounces	0.035

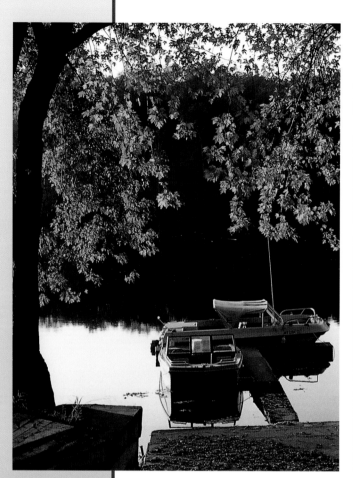
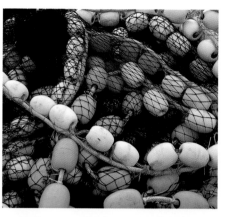
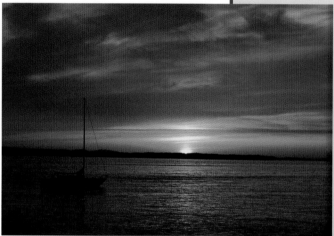
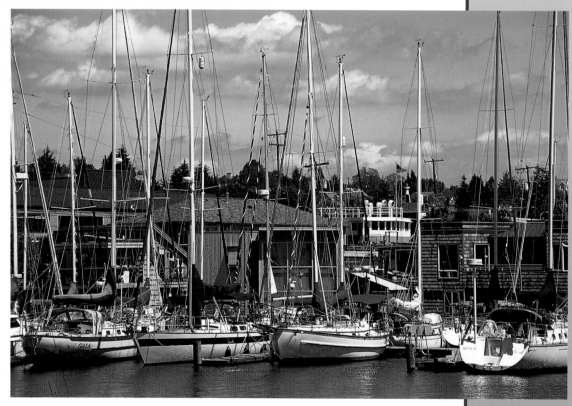

Table of Contents

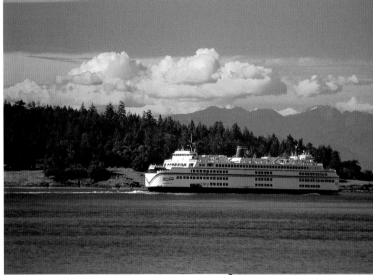

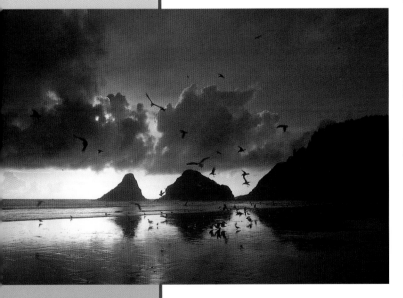

Introduction

Artist's Photo Reference: Boats and Nautical Scenes is the fourth book I have written in this series for North Light Books, this time featuring photographs of boats and related nautical scenes intended specifically for artists. As in the other Artist's Reference books, the goal is to provide painters of all mediums a handy source of images to inspire ideas and understand subjects. It is also meant to give artists who do not have easy access to nautical scenes material to work from and to furnish additional material to those who have their own reference photos. Feel free to use elements from these reference photos to inspire your work.

The boats and nautical subjects covered in this book encompass a variety of working and pleasure craft, harbors, marinas, buildings, fauna, landscape elements and much more. They were photographed under varied weather and lighting conditions and in different locales, primarily on the West Coast.

In the introductory section, you will find useful information about what kind of reference photos work best, how to avoid the pitfalls of using reference photos and a guide to shooting your own nautical reference photos, including equipment and film recommendations. Making composites from two or more reference photos, as well as effective cropping and composing, are also discussed in this section.

Interspersed throughout *Artist's Photo Reference: Boats and Nautical Scenes* are six demonstration paintings by a group of talented artists. You will see how they interpret their reference

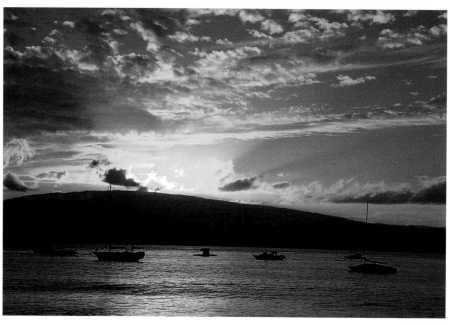

photos in their preferred medium, including watercolor, oil, acrylic, pastel and colored pencil. Each demonstration also explores various means of using reference photos to aid you in how to create exciting nautical paintings.

You may ask, "If I use the photos in *Artist's Photo Reference: Boats and Nautical Scenes*, am I violating copyright laws?" The answer is "yes" and "no." "Yes" if you paint the photographs exactly as they are and attempt to pub-

licly display or sell the results. "No" if you alter the painting enough from the reference photo that it cannot be recognized. You are free to make enlarged copies of the reference photos in this book. If an employee at a copy center questions you, show them this: *It is permissible to copy the photographs in this book.*

The images in this book are references. In other words, they are not necessarily photographic works of art with perfect settings, lighting or composition. Some of the photos herein may have flat or high contrast lighting, obstructions, shadows or photographic distortions. The book's intention is to give a quick and easy way to know what various nautical subjects look like and to solve problems like, "I live in Nebraska and want to paint a lighthouse. There is a blizzard outside and I don't feel like going to the library to find a reference photo."

Whether you use the photos in this book or use your own you will be surprised at what you can achieve with a little imagination.

Gary Greene
April, 2002

A slide is a first-generation image and produces the ultimate reference photo. Color accuracy and detail is unsurpassed by any print, especially when fine-grain slide film is used. The slide is separated into four colors: magenta, cyan, yellow and black. A plate is made from each separation, then all four colors are brought together again when the page is printed.

Color reproductions in magazines and books use a process called four-color offset printing. The offset reproductions are reasonably accurate but can't rival photographic prints or original slides in color accuracy or sharpness.

Made from either a negative or transparency (slide), a photographic print is a second-generation photo most artists prefer to work from. Custom prints, made by hand, are preferable to machine-made prints because exposure, color and cropping can be more finely tuned. Photographic prints are only as good as the operator who makes them, so use a professional lab to make your enlargements.

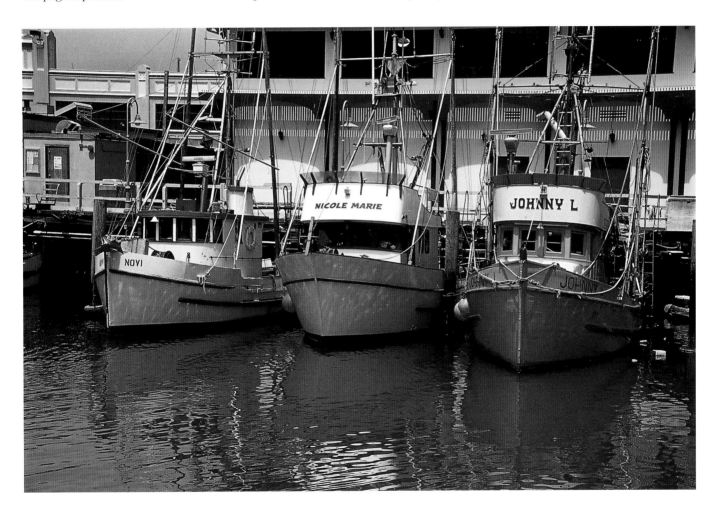

Making Your Own Reference Photos

Photography can be intimidating—get over it! Understanding the basics of photography will enhance the creative process by improving your knowledge of lighting, composition and design.

Taking Your Own Photos

Light is probably the most important element in any photo. As a rule, the best natural lighting occurs two to three hours after sunrise and before sunset. Sometimes called the "golden hours," this light is warmer and more pleasing than overhead sun, producing better modeling of light and shadow.

An overcast sky produces photos with flat lighting and little contrast. If you see an interesting subject, shoot it anyway and improve the lighting in your painting or combine it with another photo.

Perfect composition is not necessarily a must for reference photos. You can opt to shoot only the elements you think are important for your painting. However, it may be useful to remember a few simple "rules" of composition:

❀ Have a strong center of interest.

❀ Use the rule of thirds.

❀ Use objects in the foreground to lead the eye into the composition.

❀ Look for unusual lighting or atmospheric conditions, interesting objects and patterns or colors.

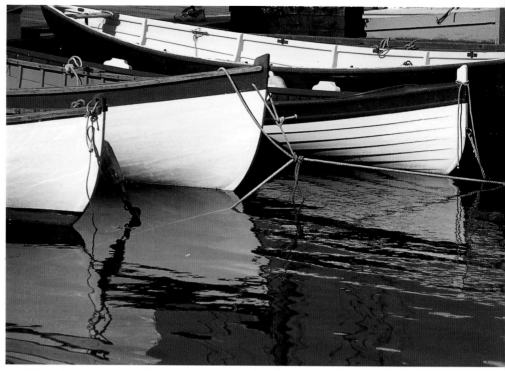

The Rule of Thirds

Divide the image into three zones horizontally and vertically and place the center of interest near any of the intersections of the imaginary lines delineating these zones. Include a foreground, middle ground and background.

After a few successes with the camera, you just might find yourself turned on to photography, too!

Photographic Distortion

Cameras do not "see" things in the same way as the human eye. A common mistake artists make is incorporating photographic distortions into their paintings. If you use a wide-angle (28mm) lens with a 35mm camera and tilt the camera away from the ground, vertical lines will become grossly distorted in the photograph. This distortion becomes more pronounced as the focal length of the lens decreases. For example, tall, relatively close subjects, such as large ships, masts and lighthouses, lend themselves to distortion.

A telephoto lens creates a different kind of distortion. The lens seems to compress the space between objects, making distant objects appear closer to those in the middle and foreground. As a lens focal length increases, the more this phenomenon becomes apparent. For example, if you use a telephoto (400mm) lens to shoot a sailboat in the distance and there are mountains in the background, the mountains will appear to be directly behind the boat.

The so-called "normal" (55mm) lens exhibits the least distortion and produces photos most closely resembling what the eye sees.

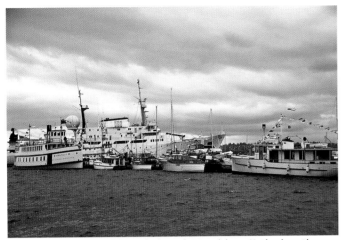

This photo was taken with a telephoto (400mm) lens. Notice how the objects appear to be next to each other.

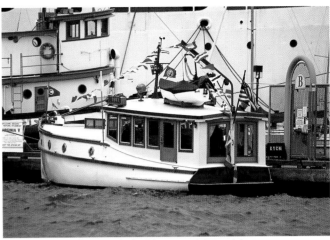

The same scene photographed with a normal (55mm) lens.

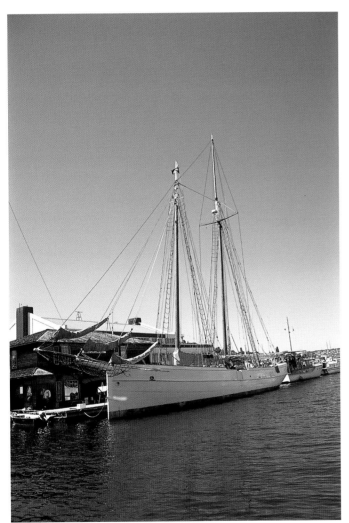

This image has been distorted by a wide-angle (28mm) lens tilted away from the ground.

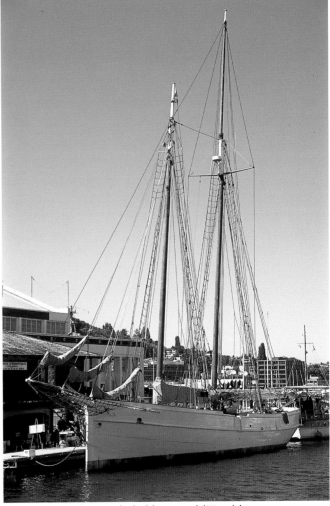

The same scene photographed with a normal (55mm) lens.

Altering Reference Photos

Altering reference photos can be as much fun as painting them. Computer expertise is not necessary to alter photos. Satisfactory results can be obtained with a copier, craft knife and an adhesive such as rubber cement.

As personal computers become commonplace, more artists are becoming proficient with them. Not long ago, image-editing programs like Adobe Photoshop were a mystery to everyone except experienced designers, illustrators and photographers. Today, many artists use image-editing software to alter or enhance photos.

If you see an interesting subject but conditions are less than desirable, shoot the photo anyway. For example, the lighting may be unsatisfactory, there may not be time to compose the shot properly, the subject may be out of range or there may be unwanted elements in the scene.

Let's say you find a stately old lighthouse in a scenic setting. Unfortunately, it's a heavily overcast day with a flat, uninteresting sky. With a little creativity, you can transform the scene digitally by combining it with a photo of dramatic clouds and an interesting foreground.

Uncropped Reference Photo

Cropping Photographs

It's easy to crop a photo. Form a window with four pieces of paper over the areas to be cropped and adjust them until you have the desired composition. It may be necessary to enlarge the cropped area with a copy machine. When using image-editing software, simply select the area to be cropped and print it out. You can produce much stronger compositions, by cropping distracting elements from reference photos.

Cropped Reference Photo

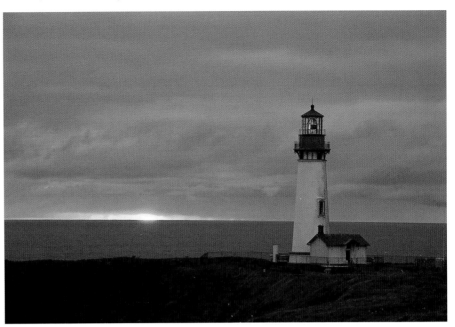

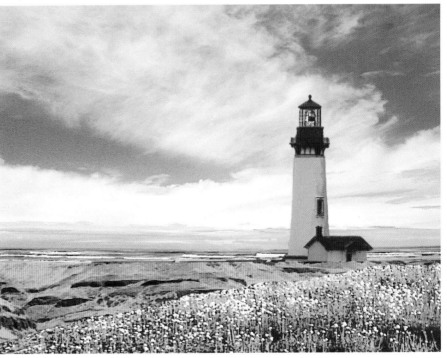

Creating Composite Photos

The primary reference photo (top right) and additional images (left) were combined to create the composite photo you see here (bottom right). By using image-editing techniques or a copier, you can create your own composite photographs.

Choosing the Right Film

A films speed (ISO) determines how sensitive it is to light. The faster the film (the higher ISO number), the greater its sensitivity. High-speed films (ISO 400 and up) enable you to photograph dimly lit scenes without a tripod, but have larger light-gathering particles in their emulsion, producing grainier and less detailed photos. Conversely, slower, fine-grain films (ISO 50–100) yield much sharper photos that hold up to higher magnification without image deterioration.

Suggested slide films for nautical scenes are Fujichrome Provia 100F (ISO 100) and Velvia (ISO 50). Comparable slide films are Kodak Ektachrome 100ES and Ektachrome 100SW. Because these are professional films, they are only available at camera stores or photo labs. Make sure they have been stored under refrigeration and check the film's expiration date.

Digital photography has become popular with artists because digital cameras are small, portable and easy to use. Instead of buying film and waiting for it to be processed, images can be immediately downloaded to a computer and inexpensively output on a home printer. Digital photography does have its negatives (no pun intended), however. Color rendition and sharpness, even at the highest resolution, cannot compare to fine-grain film images. At this writing, consumer digital cameras have a maximum resolution of 5 to 6 megapixels compared to the equivalent of 20 megapixels for fine-grain 35mm film.

Suggested Photo Equipment

(Approximate street prices as of this publication are given in parentheses).
Autofocus 35mm SLR camera: ($250 and up)
Wide-angle to long telephoto lens 28 to 300mm: ($275 and up)
Protective filter 81A: ($25 and up)
Optional Polarizing filter: ($50 and up)
Tripod with ball head and quick release: ($150)
Camera bag: ($75 and up)

35mm SLR Autofocus Camera and Two Zoom Lenses

As stated earlier, film is still a clear choice over digital photography and a 35mm single-lens reflex (SLR) camera is the preferred choice for reference photography. SLR cameras enable you to interchange lenses of different focal lengths, and most SLRs have manual exposure metering capability, a must for successful photography. Reliance on auto exposure, even with the most sophisticated cameras, can result in poorly exposed photos and disappointment. Auto focus is a useful feature for nautical photography because the subjects may be moving and require quick shooting to capture them. All SLR cameras made by major manufacturers such as Canon, Nikon, Minolta and Pentax are of excellent quality, and many are relatively inexpensive.

So-called point-and-shoot and APS (Advanced Photo System) cameras have optics that are not as sharp as SLR cameras because they are designed for snapshots. In addition, most point-and-shoot cameras do not have manual exposure capabilities, an important feature. APS cameras have two significant deficiencies; they use a film format smaller than 35mm, resulting in poor enlargements, and slide film is not available for these cameras.

Lens

Lens choices for nautical photography encompass a wide range of focal lengths. Since many nautical subjects are large, wide-angle focal lengths are needed for close work at docks, marinas, etc. On the other hand, only a long telephoto lens can bring in a distant sailboat. Zoom lenses that feature an extremely wide range of focal lengths, such as a 28–300mm lens, are convenient but may produce photos that are not as sharp at extreme telephoto settings. These lenses are also "slower," that is, have less efficient light-gathering capabilities, which may force you to use a tripod in low-light situations. A better choice is two lenses, for example, 24–105mm and a 100–300mm zoom lens.

The Filter Factor

Always place a filter on your lens to protect its front element from dust and scratches. Many photographers use clear UV or Skylight filters, but an 81A filter is a better choice. Its slightly orange color "warms up" photos without altering them, which is particularly useful on overcast days.

Tripod

Many photographers avoid tripods because they are clumsy, heavy and sometimes complicated to use. The bad news is that you may need a tripod to get sharp, detailed pictures in low-light situations. The good news is that some of the tripod hassle can be mitigated by using one equipped with a ball head and quick release instead of the standard pan head. Ball heads allow easy camera positioning without fumbling with levers. A quick release features a small plate that attaches to the bottom of the camera and immediately locks it onto the tripod without using a screw mount. The camera is easily released from the tripod by flipping a lever.

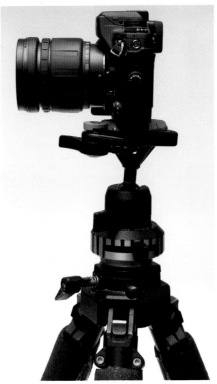

Tripod with Ball Head and Quick Release

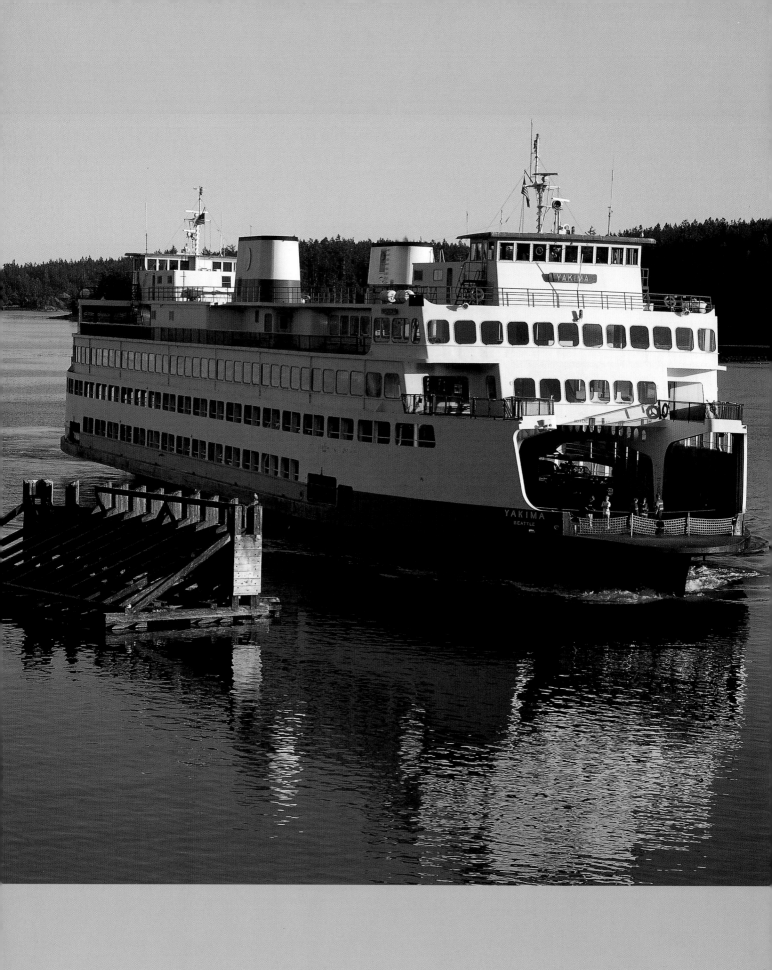

Commercial Boats

Commercial boats come in many sizes and shapes, from fishing trawlers to tugs and cruise ships. Commercial boats can be found in any locale but are more plentiful in cities and towns adjacent to large bodies of water. To add interest to your nautical paintings of commercial boats, consider details such as hulls, rigging, nets, anchors, reflections and the surrounding moorage. The reference photos in this section will give you a good start.

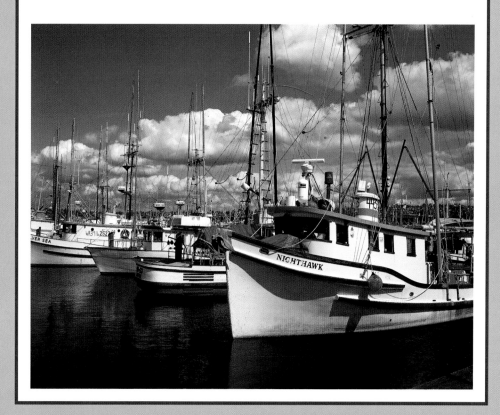

Commercial Boats

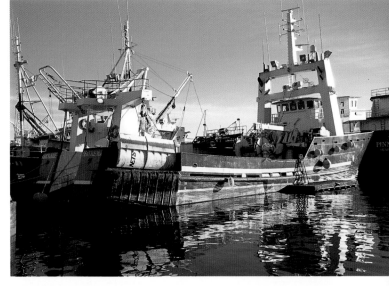

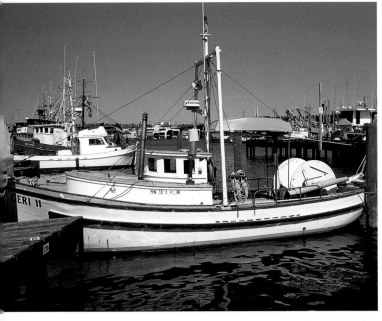

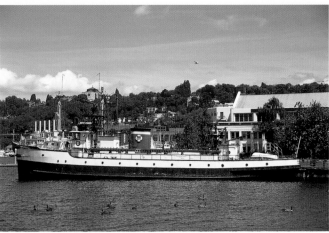

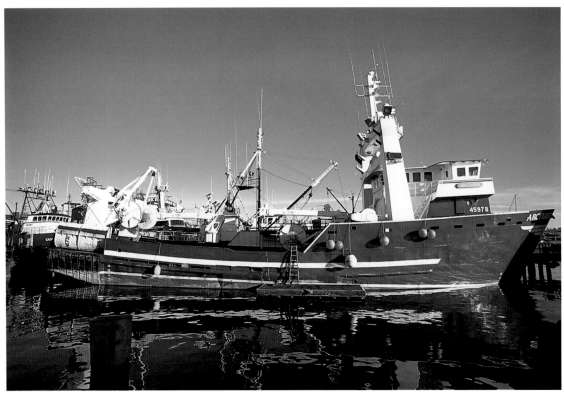

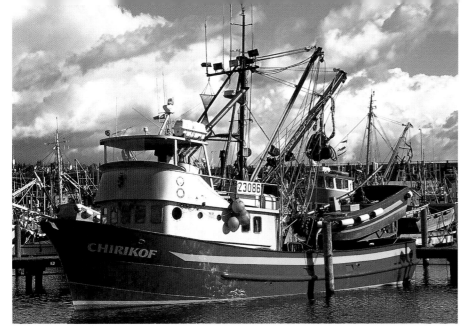

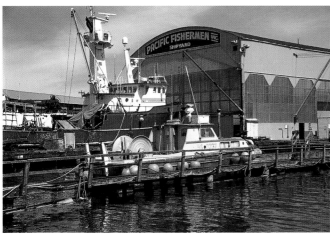

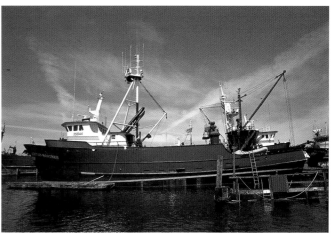

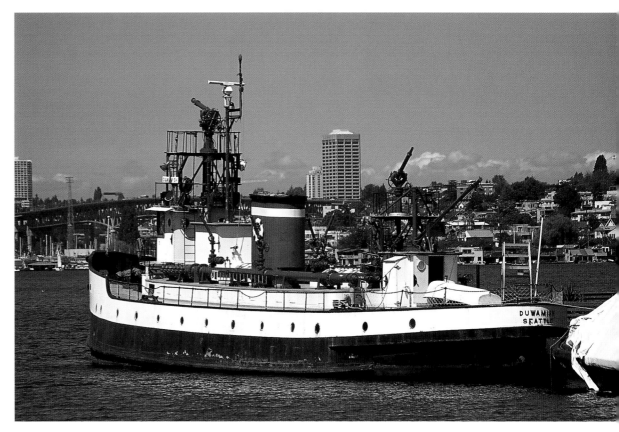

Commercial Boats

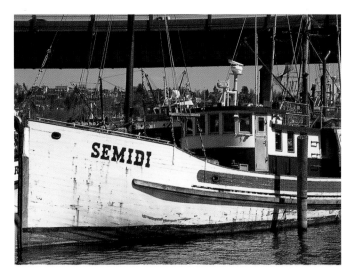

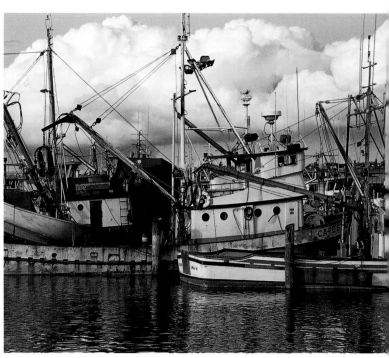

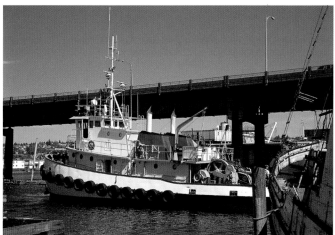

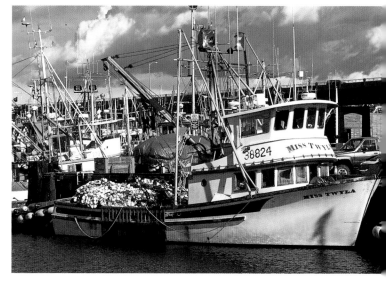

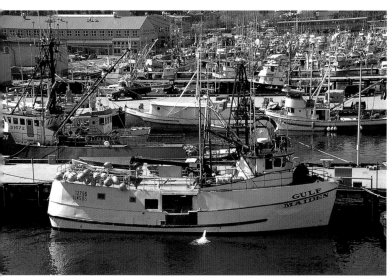

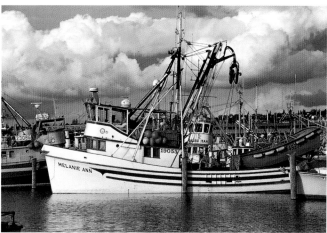

Commercial Boats

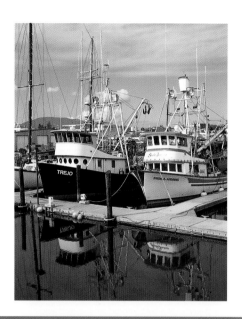

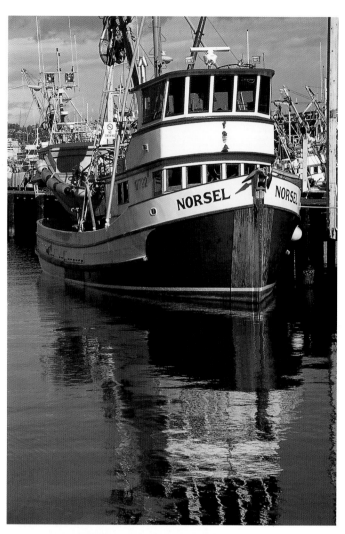

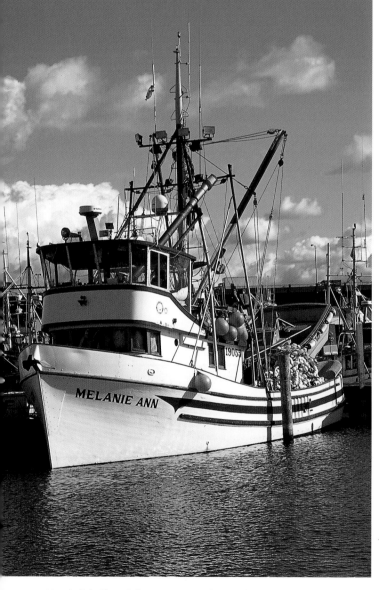

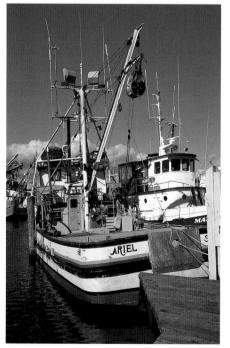

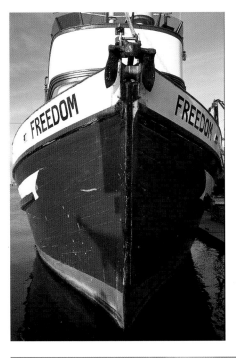

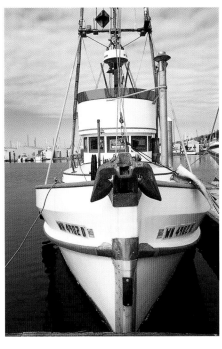

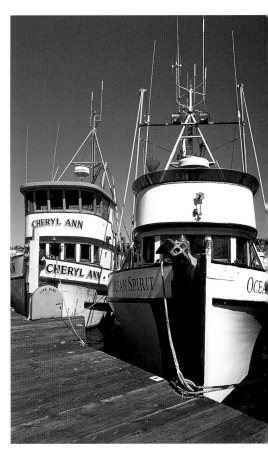

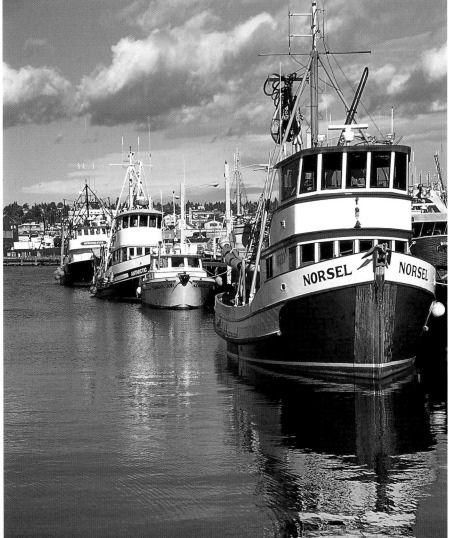

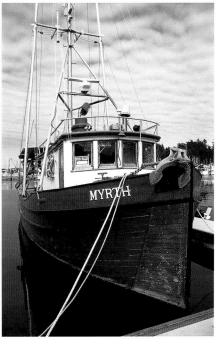

Commercial Boats

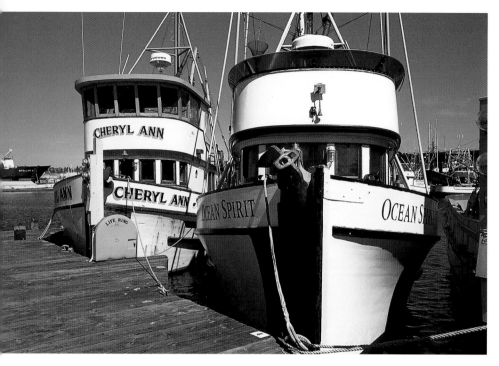

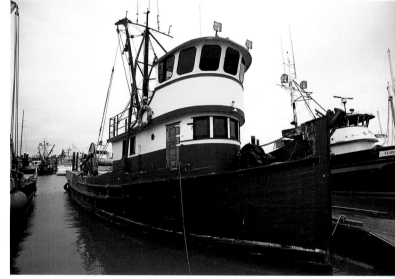

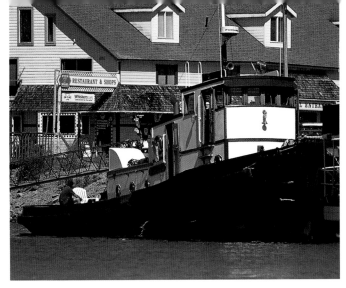

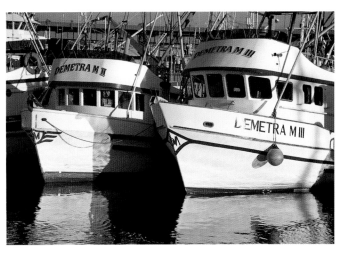

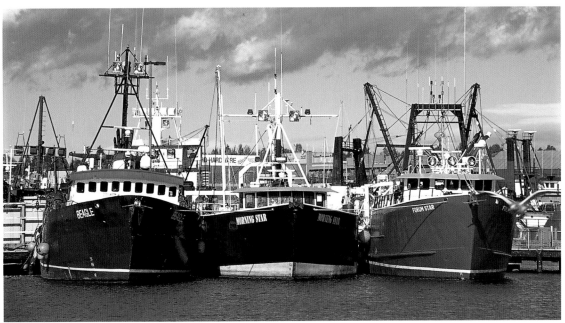

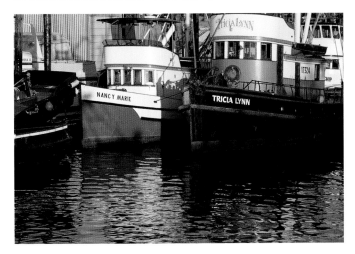

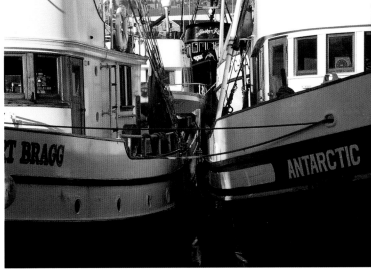

Commercial Boats

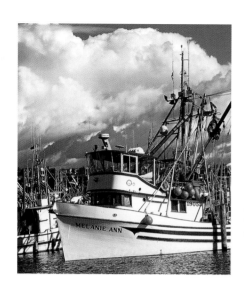

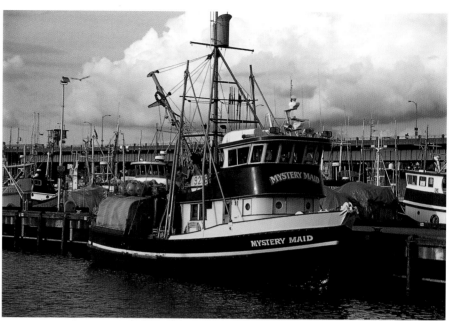

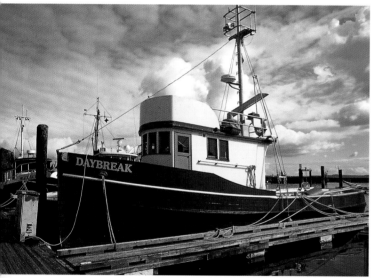

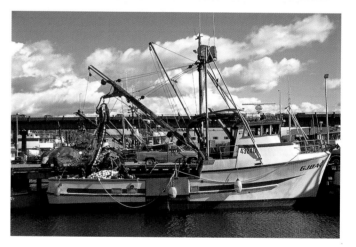

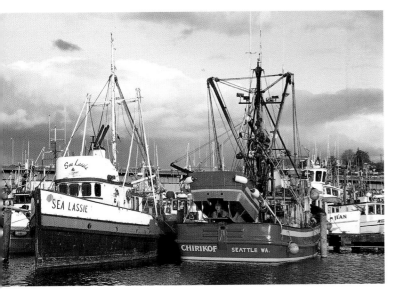

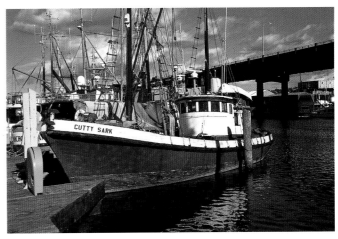

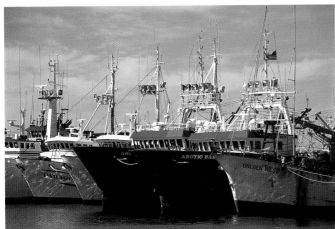

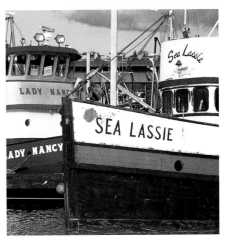

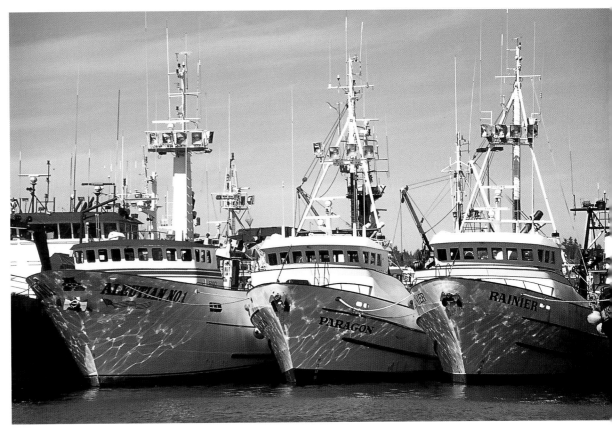

Commercial Boats

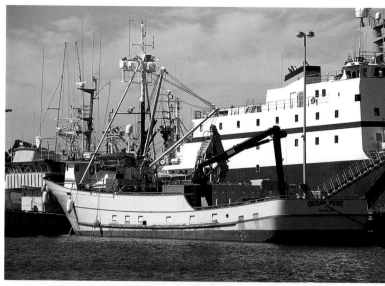

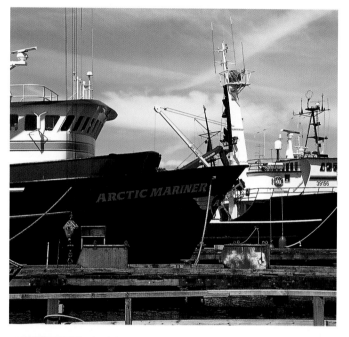

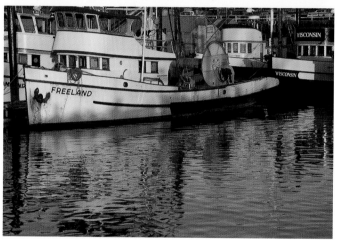

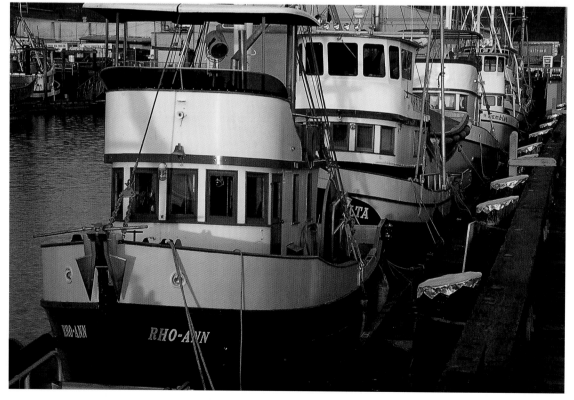

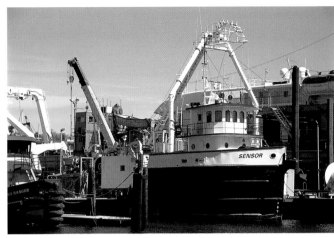

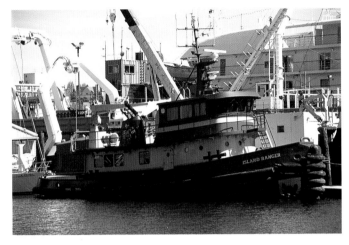

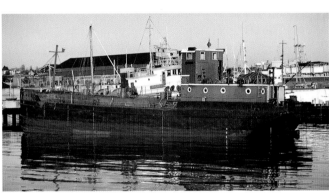

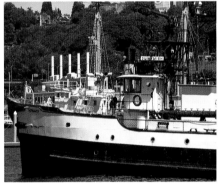

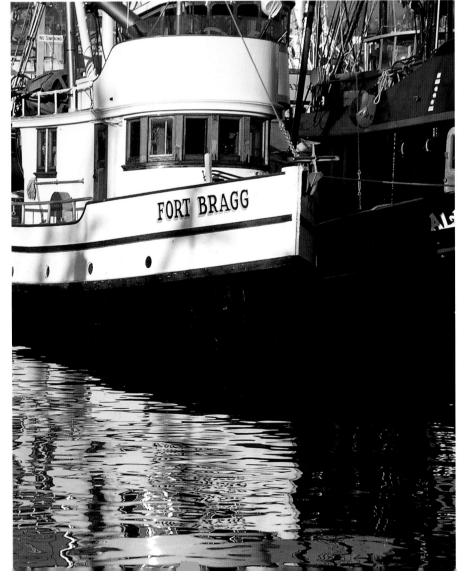

Commercial Boats

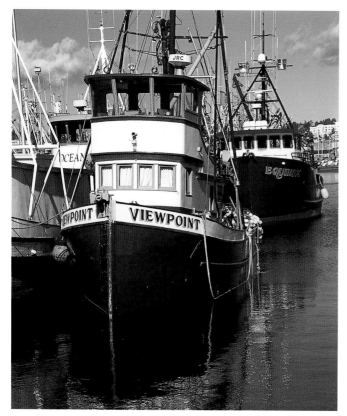

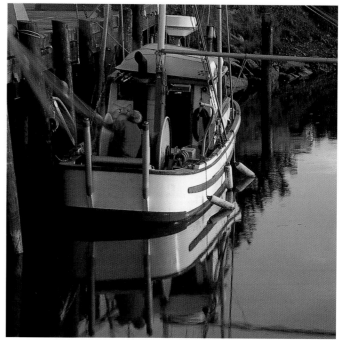

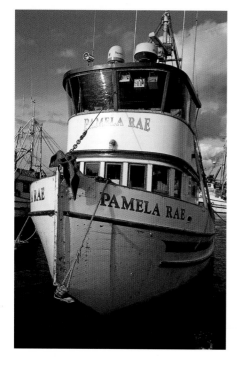

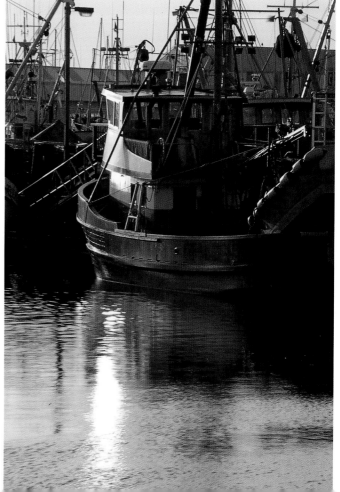

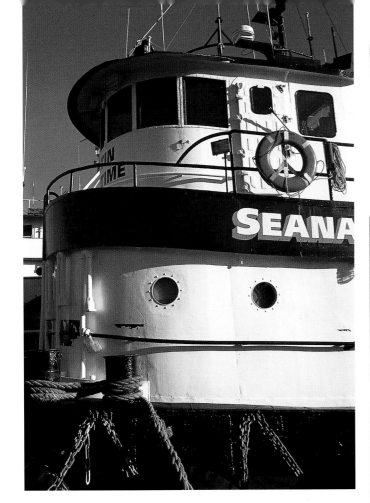

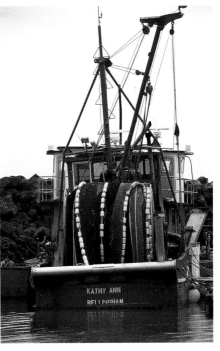

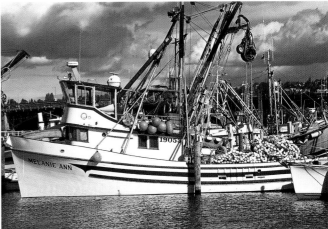

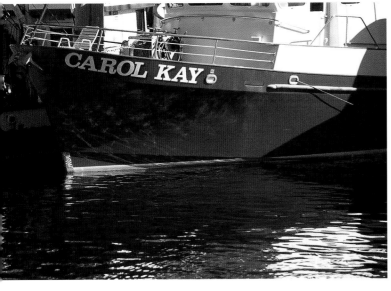

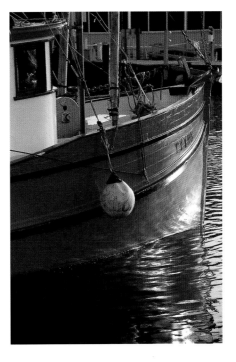

Commercial Boats

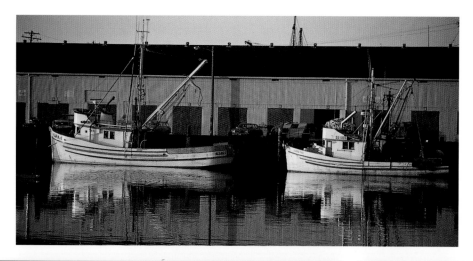

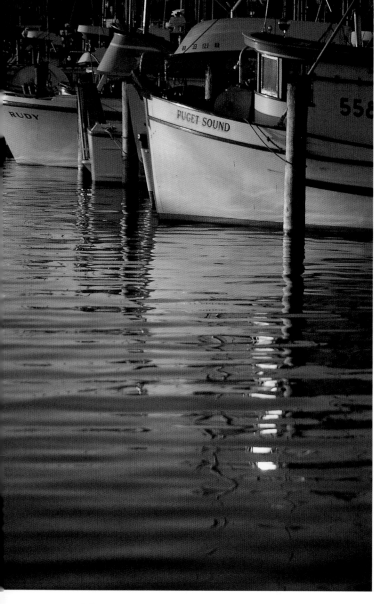

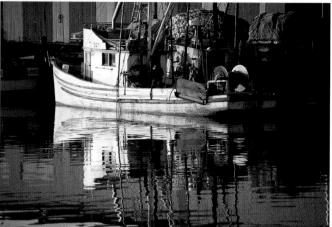

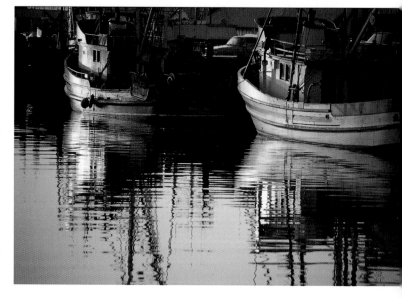

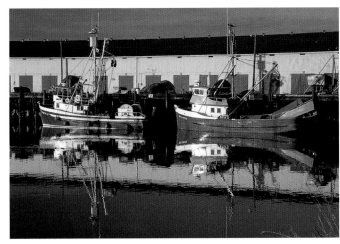

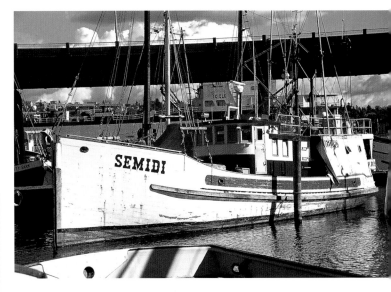

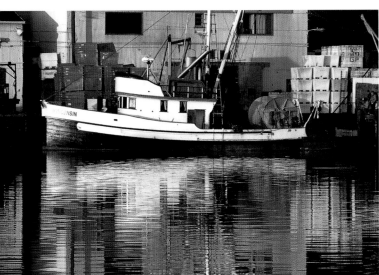

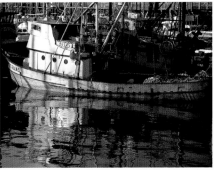

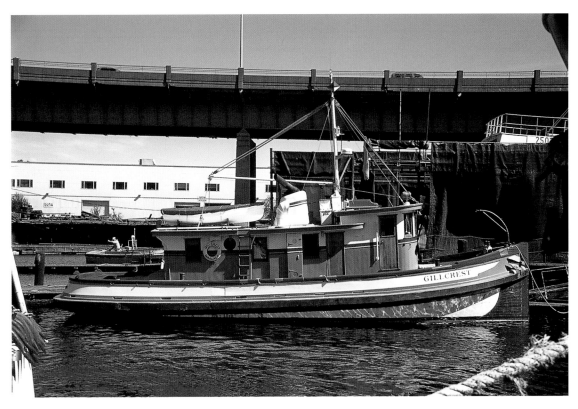

Commercial Boats

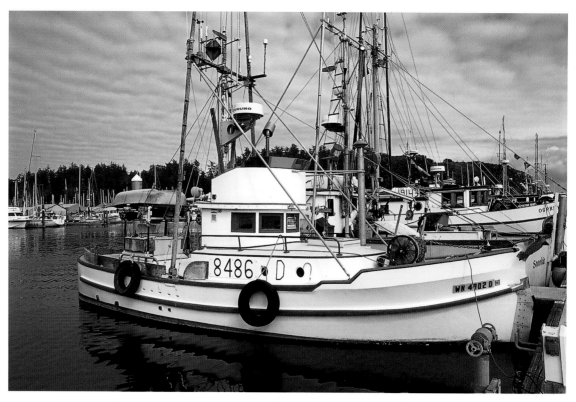

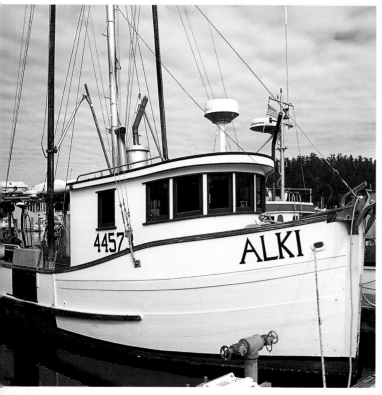

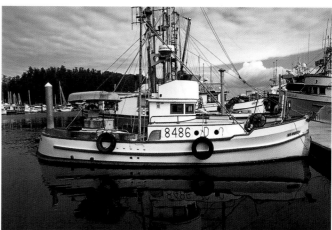

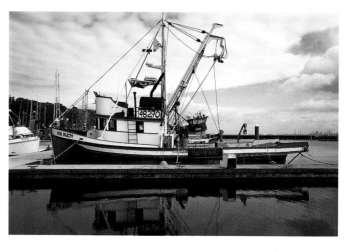

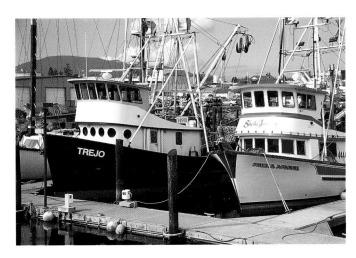

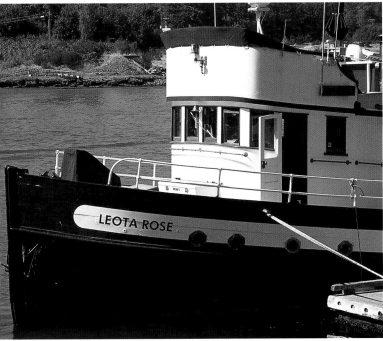

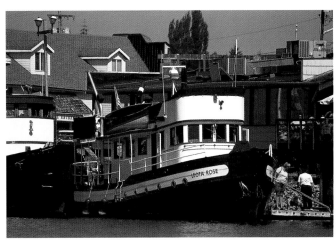

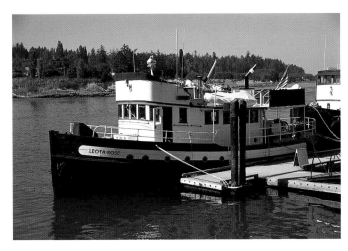

Commercial Boats

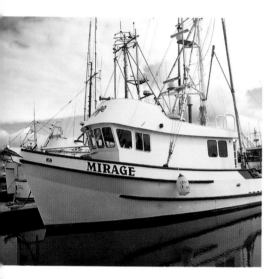

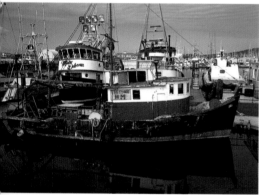

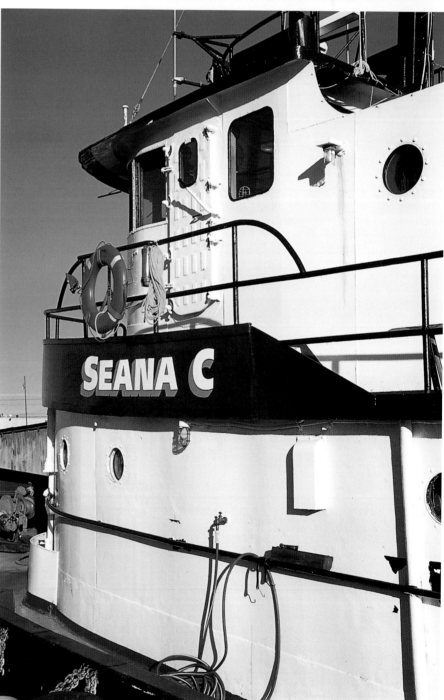

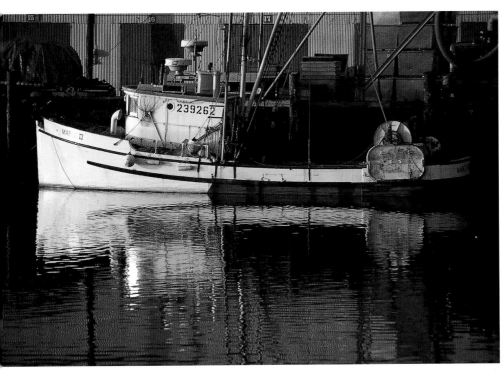

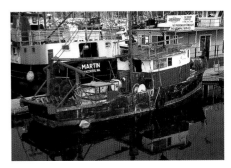

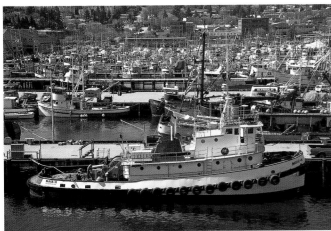

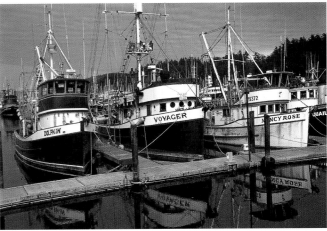

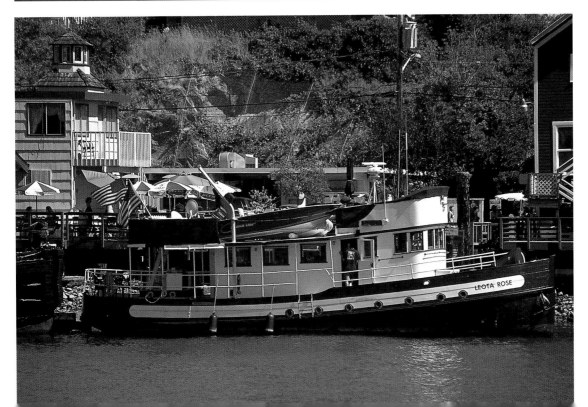

Commercial Boats

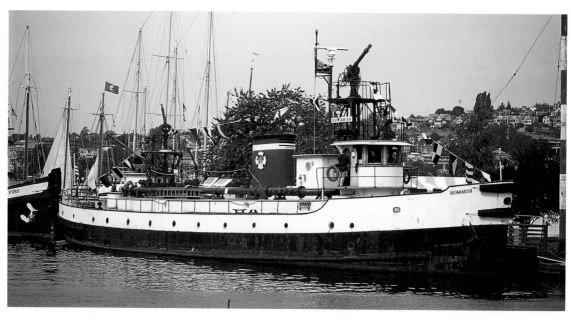

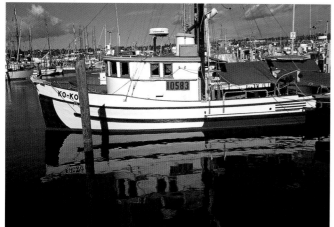

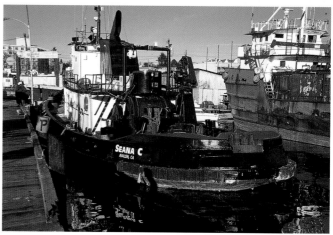

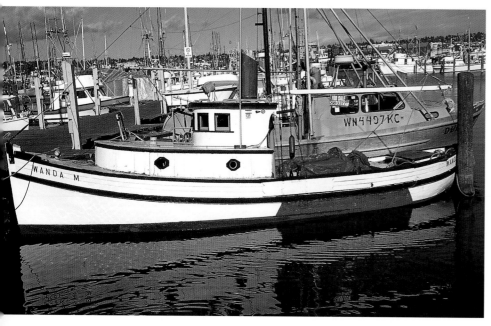

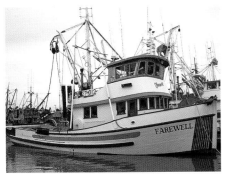

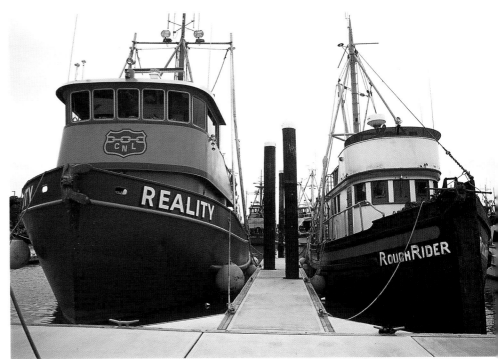

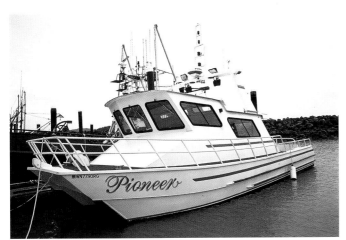

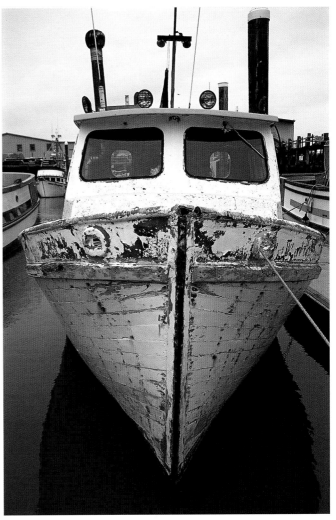

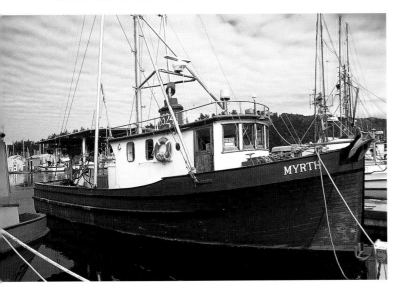

Commercial Boats

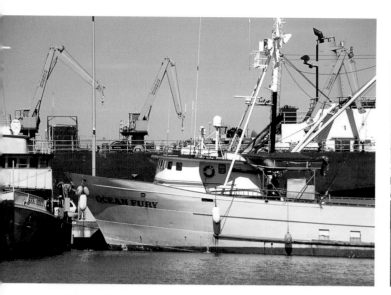

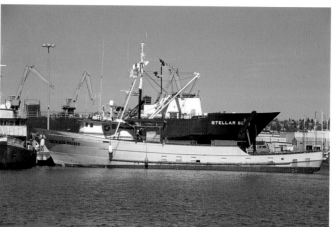

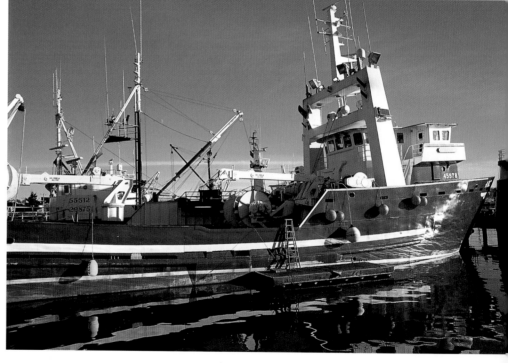

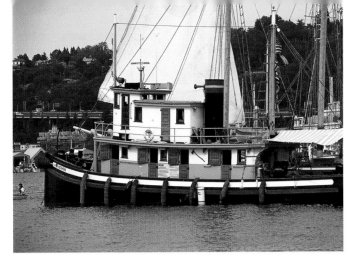

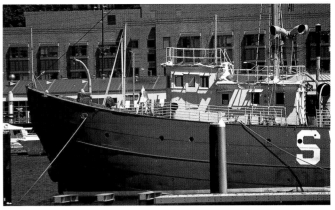

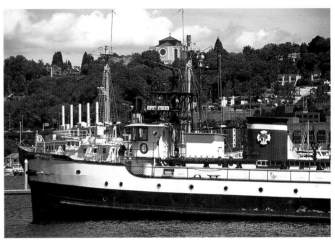

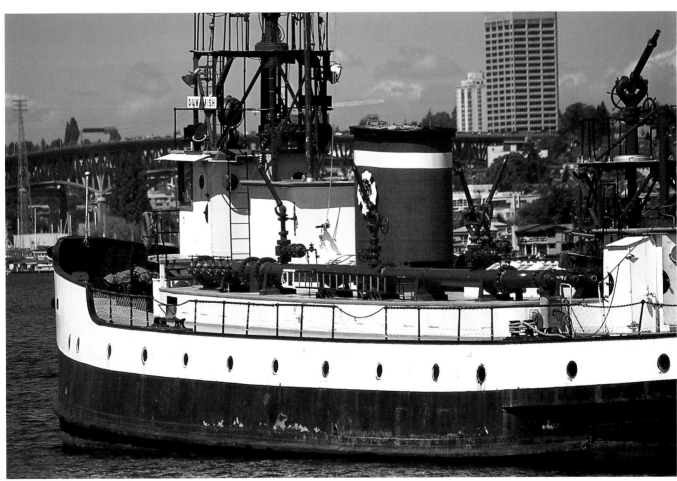

The Melanie Ann Morning in Watercolor

Materials

Surface
11" × 14" (28cm × 36cm) 140-lb. (300gsm) cold-press Arches watercolor paper

Brushes
No. 0 rigger watercolor
No. 3 round watercolor
No. 8 round watercolor
¼-inch (6mm) sable flat
½-inch (13mm) sable flat
1-inch (25mm) sable flat
2-inch (51mm) sable flat

Other
HB graphite pencil
Kneaded eraser
Masking fluid
Smooth paper towels
Toothbrush
Transparent paper
Winsor & Newton permanent gouache (white)

Color Palette

Winsor & Newton
Burnt Sienna, Cadmium Orange, Cadmium Yellow Light, Cerulean Blue, Cobalt Blue, Ultramarine Blue, Indigo, New Gamboge, Permanent Alizarin Crimson, Rose Madder Genuine

Daniel Smith
Quinacridone Gold, Rich Green Gold

While searching for subject material at a nearby boat festival, I made a far more significant find for this book: Jennifer Bowman. Reluctantly browsing through the arts-and-crafts portion of the festival at my wife's insistence, I passed by a booth of her exceptional nautical paintings. A sign read, "Original watercolor paintings of your boat from your snapshot." After a half-hour wait, during which Jennifer sold several paintings, I recruited her to contribute to *Artist's Photo Reference: Boats and Nautical Scenes*. The beautiful results are seen here.

The primary reference photo was photographed at Fisherman's Terminal in Seattle, Washington. All but the boat and water were removed in Adobe Photoshop. The secondary image of Mt. Rainier looming over Tacoma, Washington was altered by removing the protruding buildings from the middle ground. After a few minor adjustments, the two images were combined to create a working reference photo. If you do not have access to a Photoshop program, you can create a composite image by photocopying desired images and tracing elements onto tracing paper.

In her painting, Jennifer gives the middle ground a scenic look and bathes the entire scene in a warm morning glow.

Reference Photo 1

Reference Photo 2

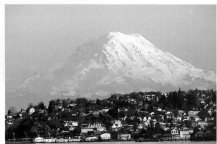
Altered Reference Photo 2

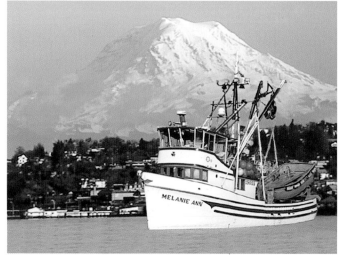
Composite Reference Photo

1. Transfer the Drawing

Place transparent paper on an overhead projector and transfer the mountain and boat images with an HB graphite pencil. With a nib, apply masking fluid to the sunlit edge of the mountain where it meets the sky and to the hull and rigging of the boat. Let the masking fluid dry.

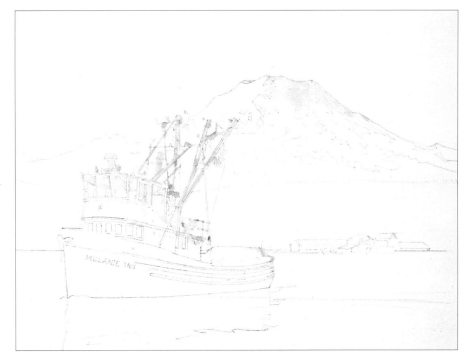

2. Paint the Sky and Mountain

Dampen the sky, background and most of the mountain with a 2-inch (51mm) flat. Avoid the masked area of the mountain. Allow the area to dry until the surface is no longer shiny but still damp. With a mixture of Rose Madder Genuine and New Gamboge, begin painting in the right side of the sky with horizontal brushstrokes. Mix Cobalt Blue and Rose Madder Genuine, and begin modeling the left side of the horizon. Paint the feathery clouds by mixing layers of Cobalt Blue, Cerulean Blue and Rose Madder Genuine. Remove the excess paint from the light areas by pressing a paper towel where you want highlights.

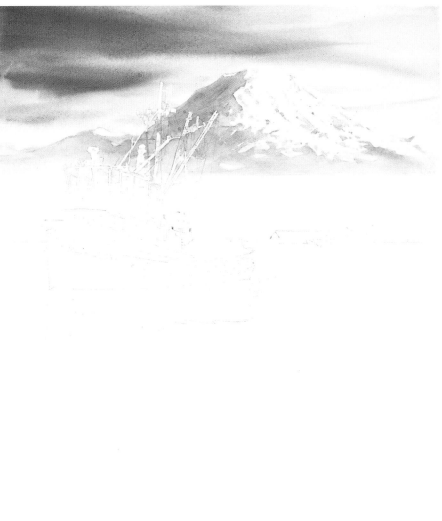

While the surface is still damp, use a ½-inch (13mm) flat to paint the shadow areas of the landscape. Mix a medium value of Cobalt Blue and Rose Madder Genuine and build layers of purple washes. Use washes of New Gamboge to create the warm pinks and oranges in the landscape. Soften the edges to give the illusion of depth. Lighten the value at the base of the mountain to give the appearance of low-lying fog, by lifting out color with a paper towel. Use a clean, damp ¼-inch (6mm) flat to lift any additional hard edges.

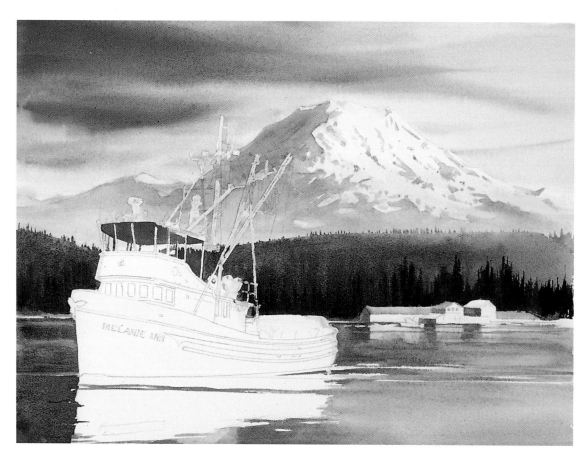

3. Paint the Hillsides, Islands and Water

Dampen the areas of the hills and islands with a 1-inch (25mm) flat. Use very little water so as not to create a bloom in the areas already painted. Mix Ultramarine Blue with Permanent Alizarin Crimson to paint the darker purple of the hills. For the evergreens, use the edge of a 1-inch (25mm) flat.

Using the same mixture, drag color upward to make the treetops appear broken. Keep the brushstrokes consistent. Blend away marks that appear too busy at the base of the trees. Using a 1-inch (25mm) flat, paint the distant hills, keeping all the edges soft. To paint the sunlit side of the hills, mix Burnt Sienna and Rose Madder Genuine. Paint around the buildings to preserve the white areas. Use Indigo and Permanent Alizarin Crimson to darken the trees behind the buildings. After the surface is dry, use pure Indigo on the edge of a 1-inch (25mm) brush for the darker trees. For fog, soften the bottoms of the trees at the shoreline with a paper towel.

After the hillside color is applied, drop in shadow areas behind the buildings using Indigo or Ultramarine Blue while the area is still wet. Use Permanent Alizarin Crimson to darken the set of trees behind the buildings. Redampen the surface and lay in the shadows of buildings using Indigo or Ultramarine Blue. Use Indigo sparingly. Block in the red buildings by painting Permanent Alizarin Crimson and Burnt Sienna in the shadows and on the roofs. When the area is dry, drag color away from the hard edges. Paint the roofs gray by adding Burnt Sienna to the mixture of Permanent Alizarin

Crimson and Burnt Sienna. With a ¼-inch (6mm) flat, paint light washes of Cadmium Orange and Quinacridone Gold over the faces of the buildings to make them appear sunlit. With a no. 8 round, dilute a mixture of Burnt Sienna and Cobalt Blue and paint in the windows and doors. When sky and background are dry, remove the masking fluid from the mountain face. Load a bit more Ultramarine Blue on a no. 8 round to add additional shadows to the mountain.

Dampen the water area with a 1-inch (25mm) flat. Dilute a mixture of Cobalt Blue and Rose Madder Genuine and paint around the reflection of the boat. Use horizontal brushstrokes to create ripples on the water. Leave some white throughout. Add additional touches of Ultramarine Blue and Rose Madder Genuine to the reflection of land. Paint darker greens by combining Indigo, Rich Green Gold and Quinacridone Gold with Ultramarine Blue to create the greens needed. For the white reflections, use vertical brushstrokes to drag color off the buildings. Mix Ultramarine Blue and Rose Madder Genuine and add touches to create the reflection of the buildings on the water. Add Cerulean Blue and Rose Madder Genuine to the right of the water surface. Remember that the still water will reflect the sky, so the sky should appear more blue than the water. For spray, add white gouache to the waterline of the boat and the crest of the waves.

4. Paint the Boat

Remove the dried masking fluid from the boat. With a ¼-inch (25mm) flat, dampen the boat with clean water. Add a mixture of Cobalt Blue and a small amount of Rose Madder Genuine to the left side of the boat. Drag the color to the right to create a lighter value on one side. Add an additional wash of Rose Madder Genuine and Cadmium Yellow Light to this area. Add Ultramarine Blue to this mixture and paint in the reflection. To give the boat volume, paint a small amount of Cobalt Blue or Ultramarine Blue to the bow. Let the surface dry.

Paint the details of the woodwork and boat name with a no. 3 round and Burnt Sienna. Blend into the Quinacridone Gold already painted. Add an additional wash of Rose Madder Genuine and Cobalt Blue to darken the shadows of the woodwork. Use the same mixtures to create more reflections in the water. Include the name of the boat in the painted reflection. Paint the lower windows with a dark mixture of Ultramarine Blue and Burnt Sienna. When dry, use Indigo to darken the left side of the windows and interior. Sprinkle a variety of colors in the windows to indicate light.

Paint the rigging with a no. 3 round and a mixture of Rose Madder Genuine, Cobalt Blue and Cadmium Yellow Light. Paint the sunlit side a warmer gray and add Indigo to darken the shadow. For the wires, use a no. 0 rigger to paint variations of gray. Paint the floats with a wash of Cadmium Orange. Add a lighter wash of Rose Madder Genuine and Cobalt Blue to

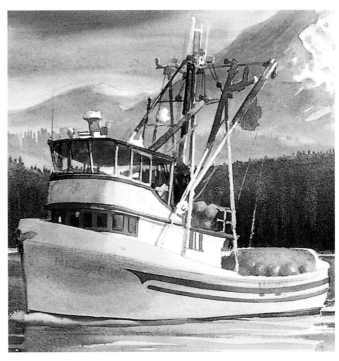

create roundness. For the cast shadows of the poles and the reflections of the wires, use a mixture of Rose Madder Genuine and Cobalt Blue. Make all of the reflections horizontal to give the impression that the boat is moving through the water. Add a dash of Cerulean Blue to the waterline to give a hint of the underpainting.

5. Apply the Highlights

Using a toothbrush loaded with white gouache, spray the bow wave. Using white gouache on a no. 0 round rigger, add highlights to the wires and rigging. Add touches of white to the sunlit side of the floatation balls and windows. Erase the pencil lines with a kneaded eraser or cover them with white.

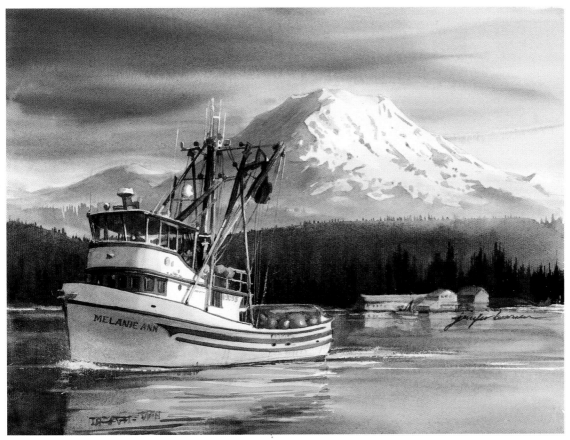

Melanie Ann Morning, JENNIFER BOWMAN, Watercolor on 140-lb. (300gsm) cold-press Arches watercolor paper, 11" × 14" (28cm × 36cm)

Barges and Tugboats

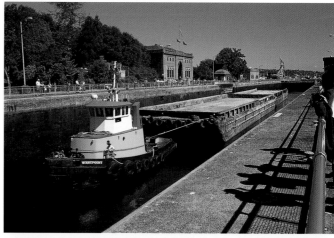

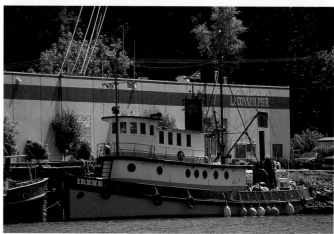

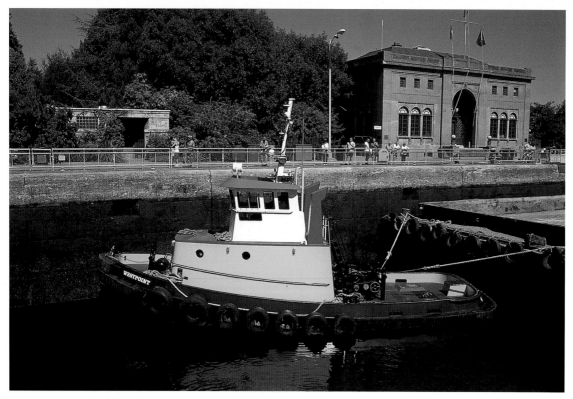

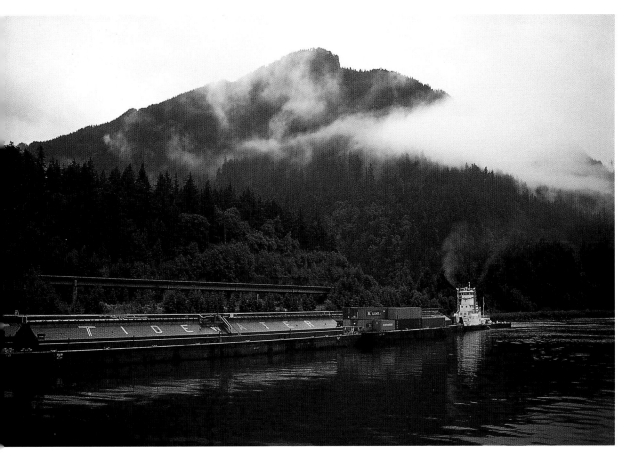

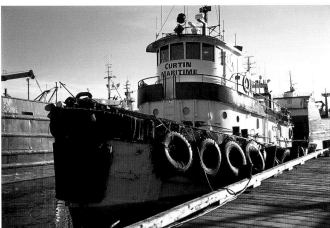

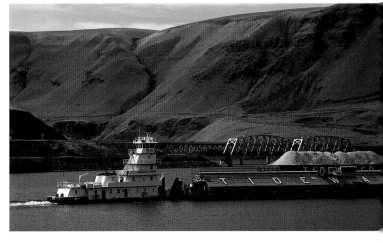

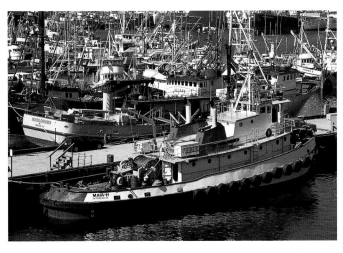

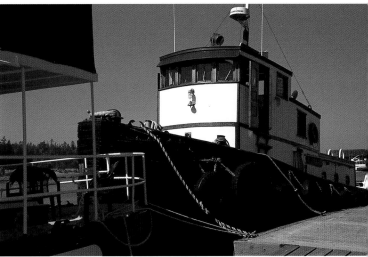

Ferries

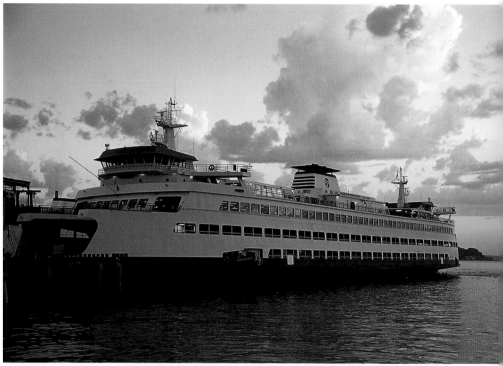

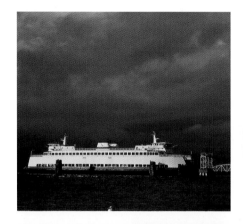

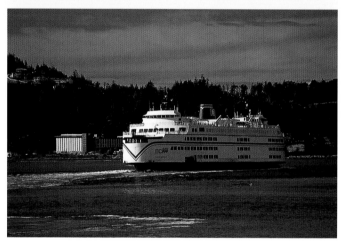

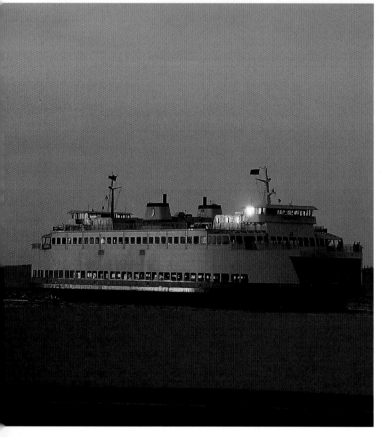

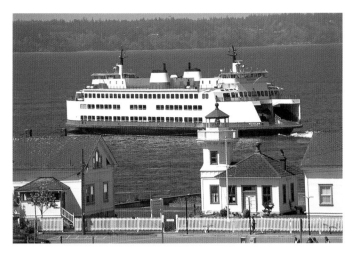

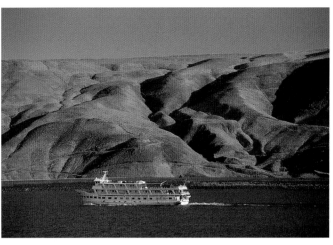

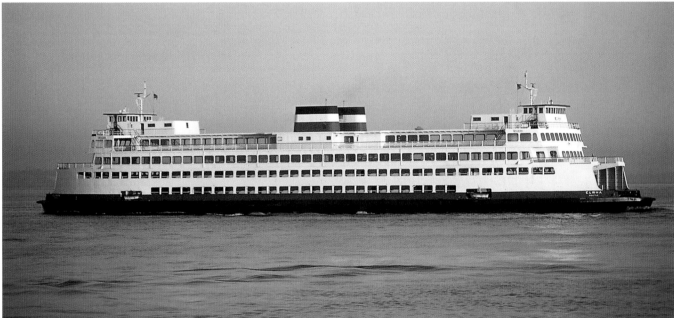

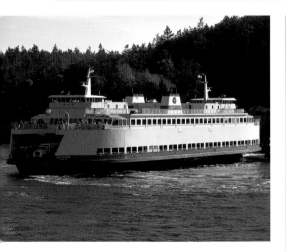

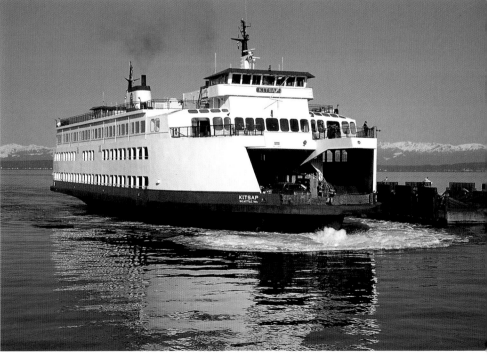

Riverboats

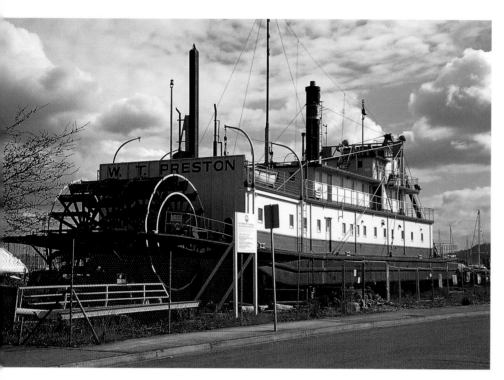

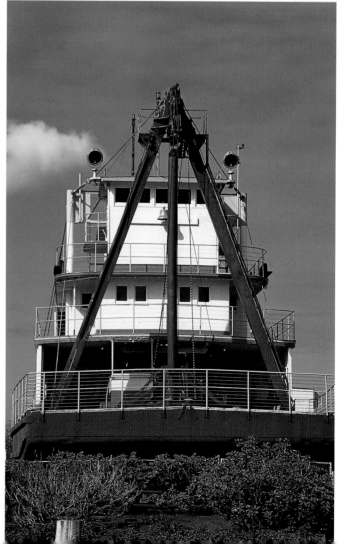

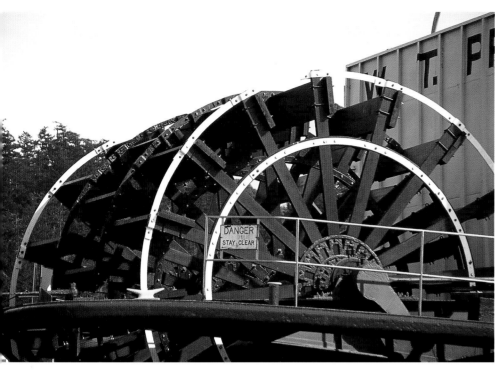

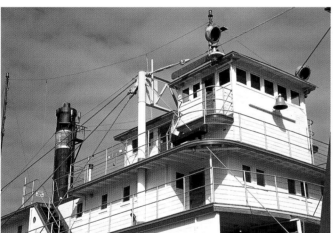

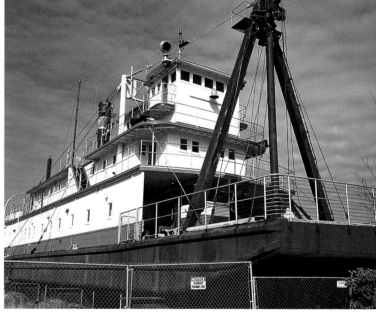

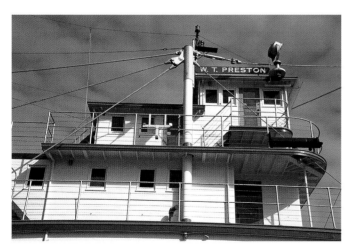

Oceanliners

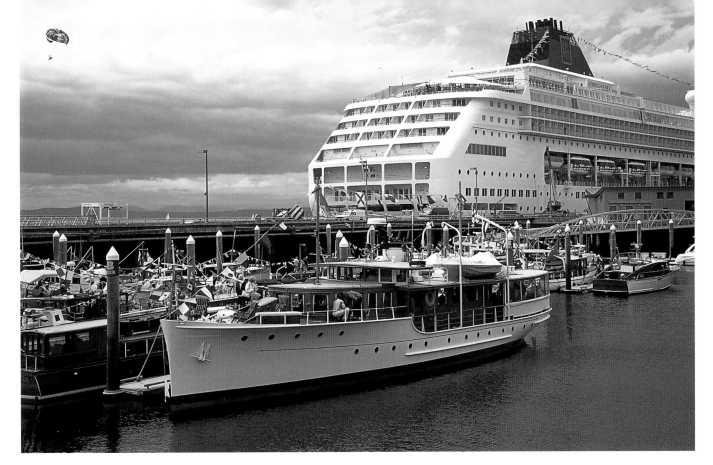

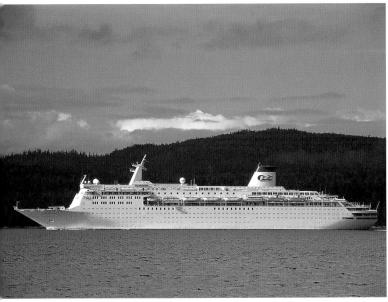

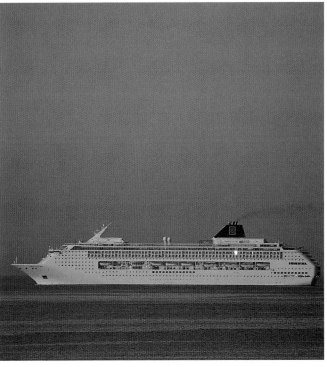

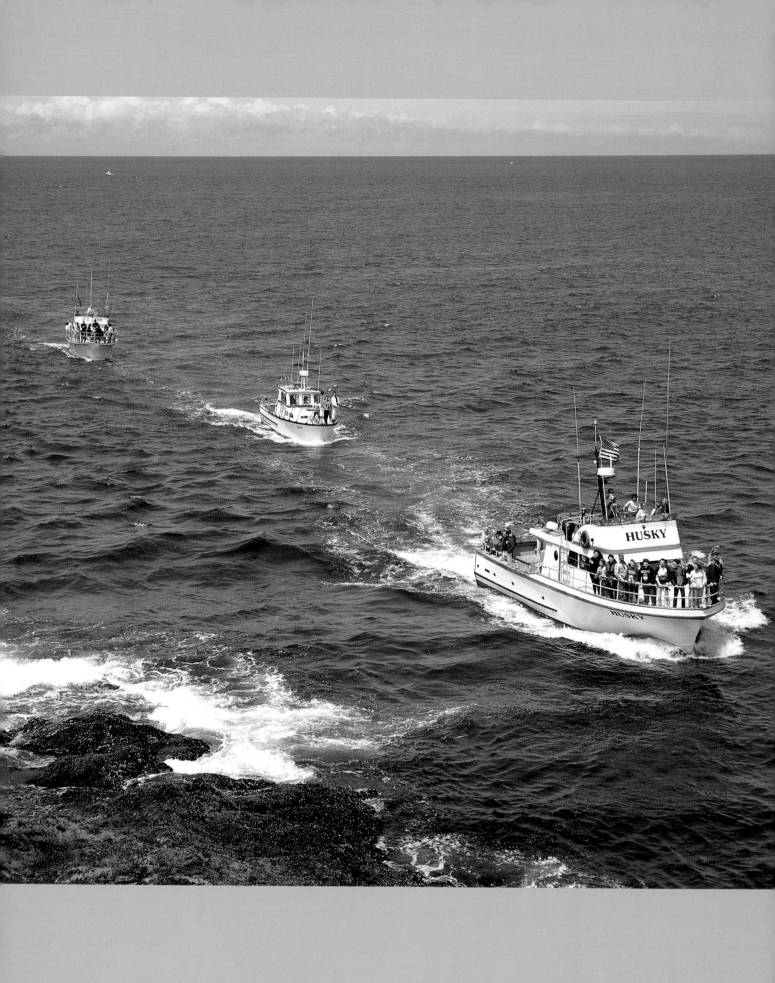

Pleasure Boats

No matter where you live, you are always within a few miles of finding some kind of pleasure boat. Whether it be a canoe on a placid river or lake, a kayak shooting the rapids or a huge multimillion-dollar yacht at an upscale marina, pleasure boats offer you a wide variety of ideas for nautical paintings and subjects to enhance a seascape.

Sailboats

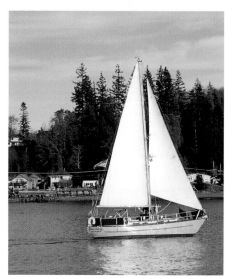

Sailboats

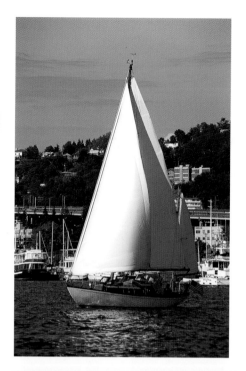

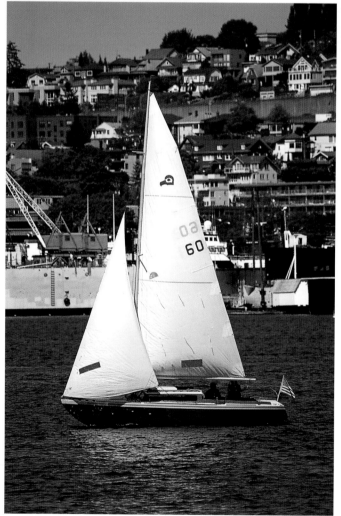

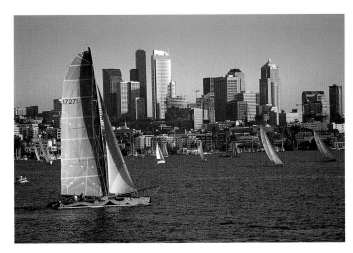

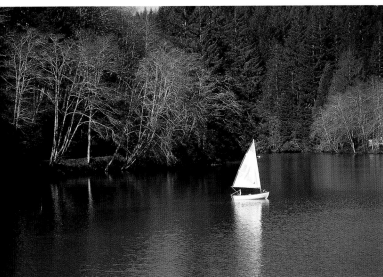

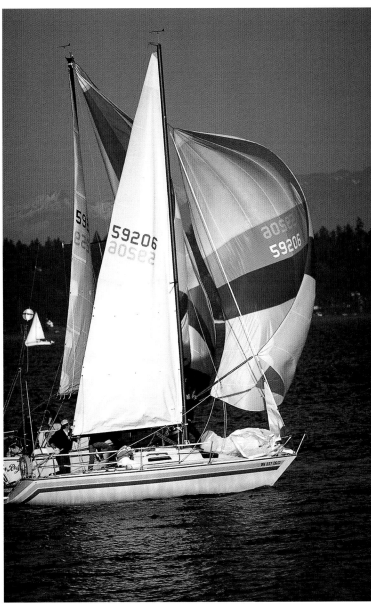

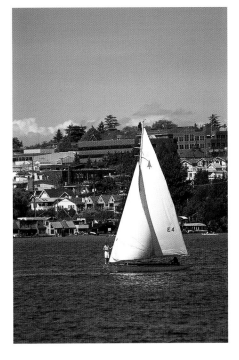

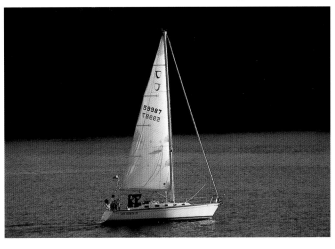

Sailboats

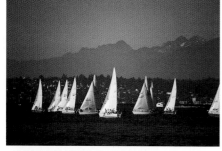

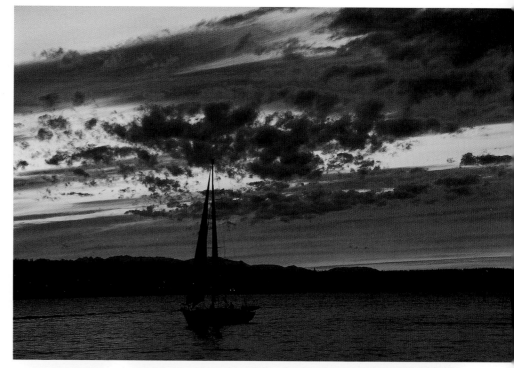

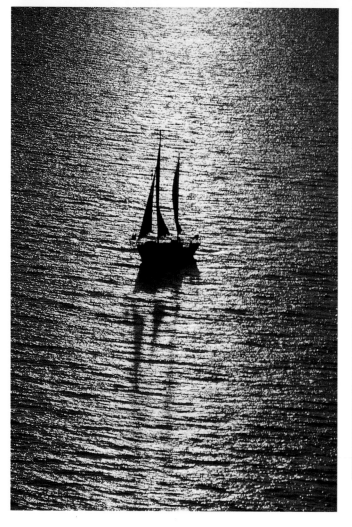

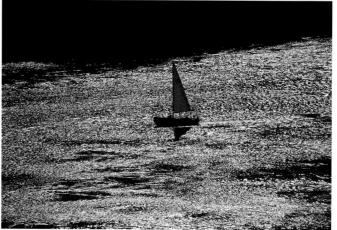

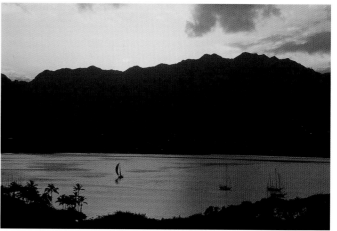

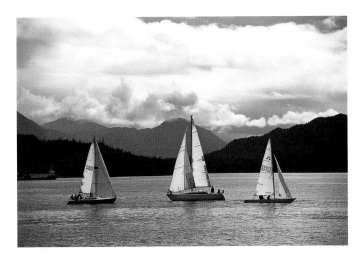

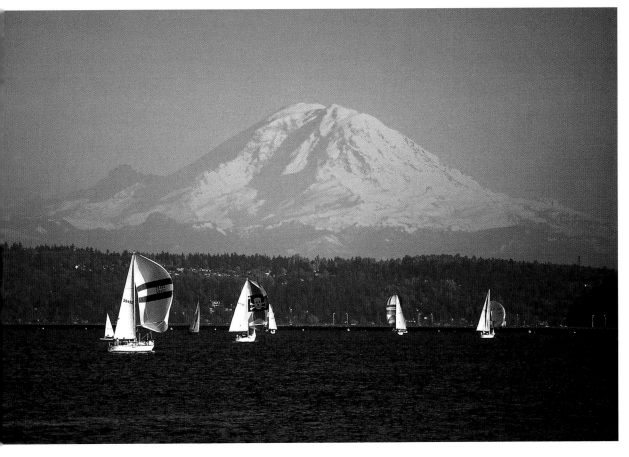

Sailboats

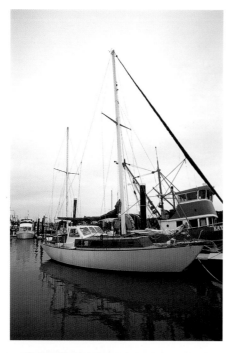

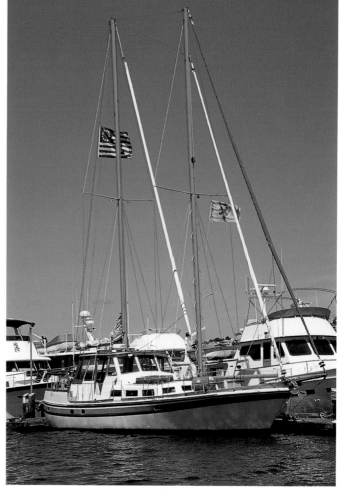

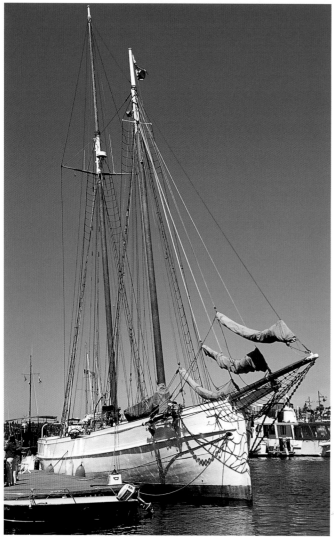

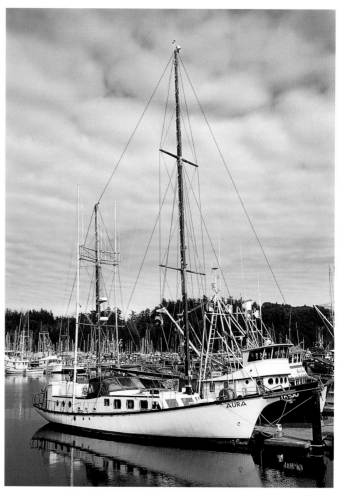

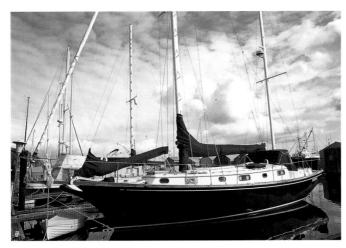

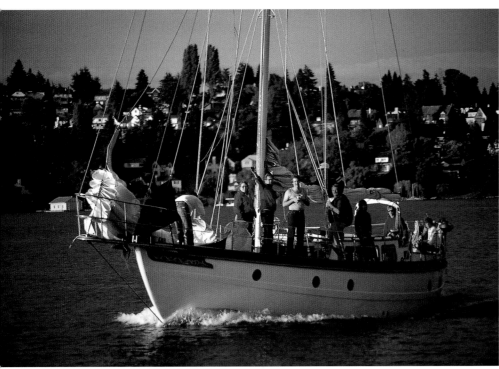

Sailboats

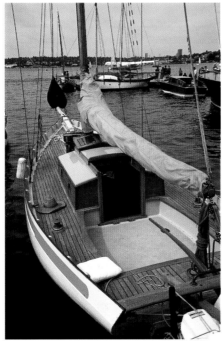

Skiffs at Ease in Oil

Materials

Surface
16" × 20" (41cm × 51cm) 300-lb.
(640gsm) cold-press Arches watercolor
paper

Brushes
No. 4, 6 and 8 round brushes
No. 2, 4, 6 and 8 flat brushes

Other
18" × 24" (46cm × 61cm) foamcore board
Acrylic gesso
Masking tape

Color Palette

MAX Grumbacher water-soluble oils
Cadmium Red Light, Cadmium Yellow
Medium, Cobalt Blue, French Ultramarine
Blue, Quinacridone Orange, Quinacridone
Red, Titanium White, Viridian, Yellow
Ochre

Boat festivals are an obvious place to find good material for reference photos. While attending a local wooden boat festival, I found a wealth of interesting vessels of all sizes, including these rowboats moored to the dock. Using a 28mm lens, I composed the image using the camera. I wanted to emphasize the strong qualities of line, form and color. Unfortunately, I was unable to crop out some of the unimportant objects in the background. Using an Adobe Photoshop program, however, I removed the distracting elements to make the final reference photo, resulting in a much stronger composition. If you do not have access to a Photoshop program, you can alter the reference photos by first photocopying your chosen subjects and then constructing an image by cutting and pasting the desired compositional elements.

Talented oil painter Ted Pankowski transformed this rather tight composition into a beautiful impressionistic scene, adding his own elements to the final painting.

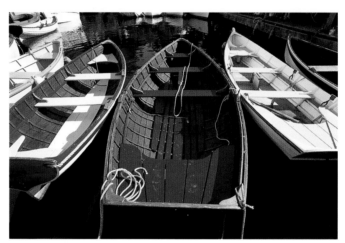

Reference Photo

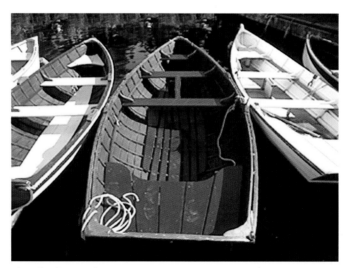

Altered Reference Photo

1. Prepare the Surface and Preliminary Sketch

Coat both sides of the watercolor paper with white acrylic gesso. When it's dry, tape the paper to an 18" × 24" (46cm × 61cm) piece of foamcore. The benefit of using Grumbacher's water-soluble oils is the flexibility of painting on paper with an oil-based medium. Like watercolors, much of the painting can be done in thin washes. Leave some areas of paper showing through.

Sketch in major shapes of the boats with a no. 2 round and Yellow Ochre. Leave out all the nonessential details and concentrate on the major shapes. If needed, lay out both the watercolor paper and the photograph in grids of sixteen equal rectangles. The grids will make it easier to transfer the image from the photograph to the paper.

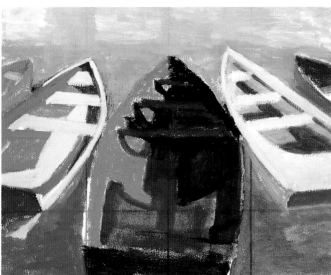

2. Block in the Drawing

Use both no. 6 or 8 flats and rounds to paint in the shapes of the boats and surrounding water. A round works well for the water and sides of the hulls. A flat brush works well for the seats and other flat surfaces.

Keep the darks and lights separated. Begin with the darks, keeping the paint thin and transparent. Use Titanium White sparingly. Block in the shadows under the seats, curves of the hulls and decking.

The edges should stay loose. It is not necessary to paint exactly within the lines of the drawing underneath. Use this stage in the painting as an opportunity to adjust perspective. Paint larger areas with a no. 6 or 8 round and use a no. 4 or 6 round for the smaller areas.

Paint the violet shadows of the red boat with a mixture of Quinacridone Red, Ultramarine Blue, Cobalt Blue and a small amount of Titanium White. Paint the bright reds on the seats with a mixture of Quinacridone Red and Cobalt Blue and a small amount of Titanium White. Add Cadmium Red Light and Cadmium Yellow Medium where the reds are brightest. For the grays on the inside hulls, lighten the mixture of Quinacridone Red and Cobalt Blue with Yellow Ochre and Titanium White.

Using a no. 4 round, paint the dark shadows of the boats to the right and left of the red boat with a mix of Cobalt Blue, Viridian, a touch of Quinacridone Red and Titanium White. Paint the sunlight inside the boats with Titanium White, Yellow Ochre and a touch of Viridian. The seats and hull are in full sun and therefore brighter. Instead of Viridian, add Quinacridone Red and a touch of Cadmium Yellow to the white mixture. Use a no. 4 or 6 flat. Paint the very backs of the boats with pure Quinacridone Orange.

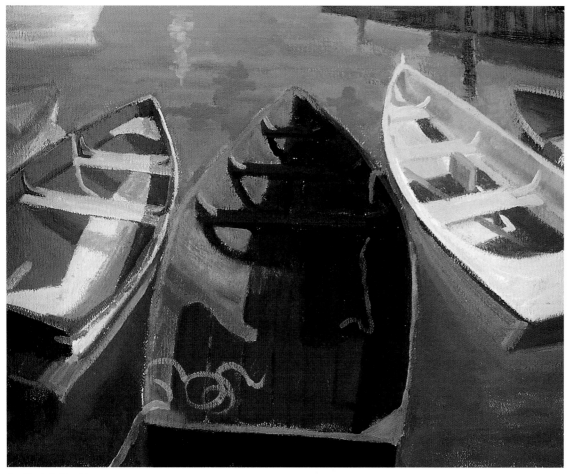

3. Model the Forms

Use no. 2 and 4 rounds to refine the drawing. Adjust the values to bring out the characteristics of each major feature. Repaint the darkest shadows with a transparent wash of Ultramarine Blue and Quinacridone Red. Touch up the sunny areas with Quinacridone Red and Cadmium Red Light. Repaint the gray areas with a violet mixture of Quinacridone Red, Cobalt Blue and Titanium White, adding Yellow Ochre where the inside hulls of the boats are brightest.

To balance the intense reds of the center boat with the blue-greens of the water, repaint the water above the boats with a bright mixture of Cobalt Blue, Viridian, Cadmium Yellow Light and Titanium White. Paint in the reflections in the water at the upper left with Titanium White and Quinacridone Red. Mix Quinacridone Red and Cadmium Yellow and paint in the shadows at the upper right. With a no. 4 round, paint in the ropes with a mixture of Ultramarine Blue and Titanium White.

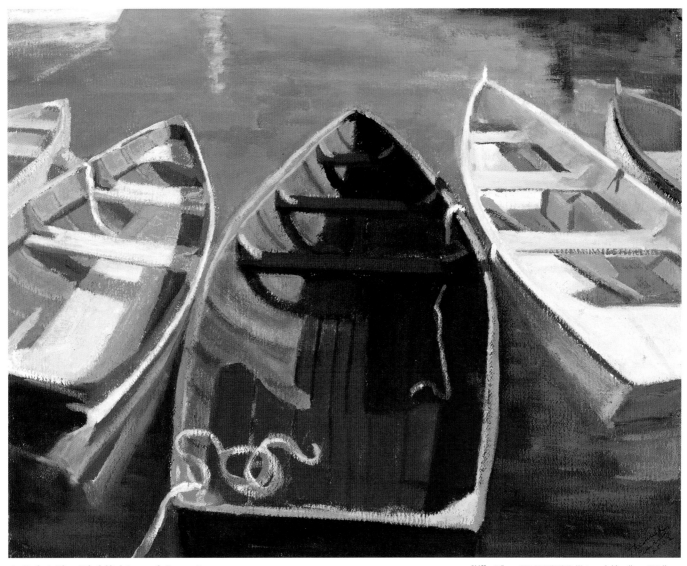

4. Paint the Highlights and Accents

Paint the highlights thickly and opaquely with a no. 4 or 6 flat. Refine the colors and shapes of the smaller details. For example, lighten some of the curves of the ropes with a touch of Titanium White.

Paint the wood trim around the top edges of the boats with bright mixtures of Titanium White, Cadmium Yellow Medium and Quinacridone Orange. Lighten the water at the top of the painting with Titanium White, Viridian and Cobalt Blue. With Titanium White and a touch of Cadmium Yellow Medium brighten up the white seats that are in direct sunlight.

Accents belong in the deepest shadows of the interiors and backs of the boats. Repaint the darker shadows under the seats of the red boat with a transparent mixture of Ultramarine Blue and Quinacridone Red. Bring attention to the skiffs by adding a dark shape to the lower right of the water using Ultramarine Blue and Quinacridone Red. To complete the painting, repaint the very back of the boats in Quinacridone Orange.

Skiffs at Ease, TED PANKOWSKI, Water-soluble oil on 300-lb. (640gsm) cold-press Arches watercolor paper, 16" × 20" (41cm × 51cm)

Antique Boats

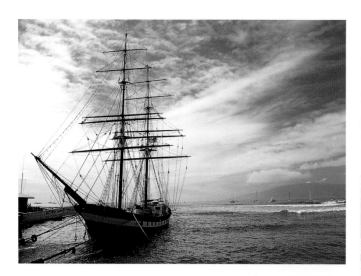

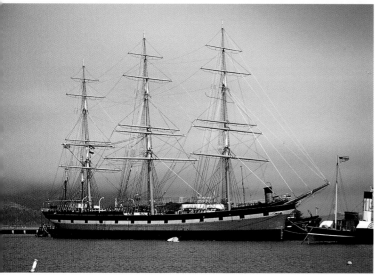

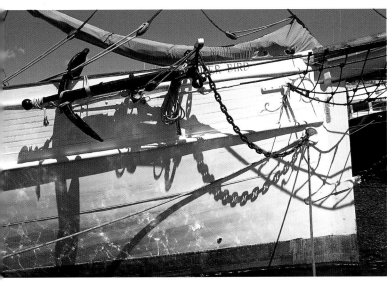

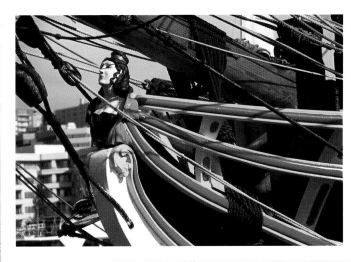

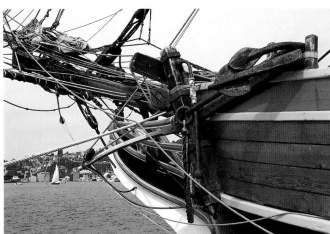

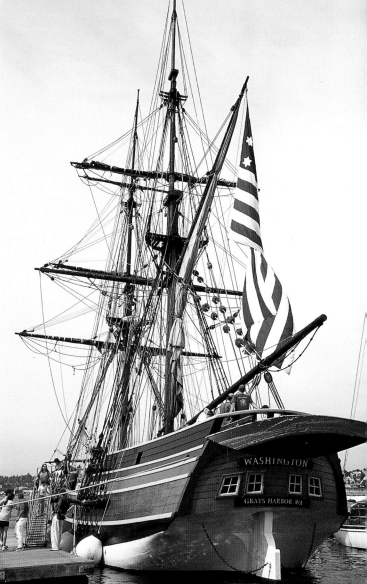

Mixed Media Lakebay Marina

Materials

Surface
13" × 17" (33cm × 43cm) 140-lb.
(300gsm) cold-press Arches watercolor
paper

Brushes
No. 0 round rigger
No. 10 round watercolor
1-inch (25mm) flat

Other
18" × 24" (46cm × 61cm) ½-inch (13mm)
Gator board
Black ultra-fine-point felt marker
Kneaded eraser
Masking tape
No. 2 or HB graphite pencil
Ruler
Soft, wide house brush
Water container
Watercolor palette
White gouache
White paper towels

Color Palette

Daniel Smith Watercolors
Alizarin Crimson, Burnt Orange, Burnt
Sienna, French Ultramarine, Hansa Yellow,
Prussian Blue, Raw Sienna

The appealing old building and pier in this photo have always been a favorite of mine, and the photo has resided in my reference photo library for a number of years. To improve the composition, I reversed the anchored sailboat from the secondary photo and added it to the foreground in Adobe Photoshop. This alteration helped to frame the rustic marina. I moved the rowboat to the right side to help draw the eye into the composition. If you do not have access to a Photoshop program, you can make an effective composite yourself using simple materials such as tracing paper or a photocopier. Artist Ross Nicoll, working in watercolor and ink, improvised the water, sky and background trees to produce this charming painting.

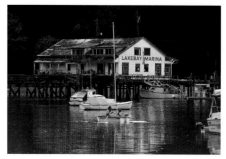

Reference Photos

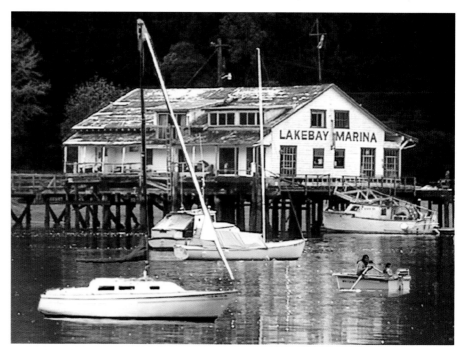

Composite Reference Photo

1. Lay Out the Painting

Tape the paper onto an 18" × 24" (46cm × 61cm) piece of Gator board. Lightly pencil in a 13" × 17" (33cm × 43cm) rectangle that is 1½" (4cm) larger than the size of the finished work. Transfer the reference photo onto the paper using a grid system. Divide a photocopy of the reference photo into halves and then into quarters. Lightly draw the same grid lines on the watercolor paper. Using these grid markings, lightly sketch in the locations of the features of the reference picture. These features are the top roofline of the big shed, the peak of its roof at the right end, the equivalent peak at its left end and the horizontal line of the dock. Next, use the grids to position the features such as the boats and deck houses. Keep the pencil work light but dark enough to see.

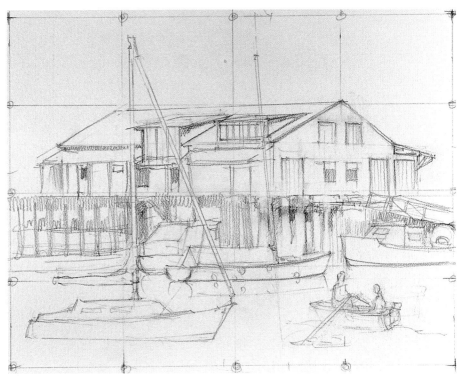

2. Define the Details

With the black marker, define certain details such as the tops of the masts. Use a ruler to draw the masts, the edges of buildings and the rigging lines. Leave the rigging lines unfinished for a later step. Draw in some of the vertical elements, such as the dock pilings and building windows. Continue to add smaller details that may have been omitted from the pencil layout. It's important to be accurate because the ink will be seen through the watercolor.

After completing the ink drawing, erase the pencil lines so the ink stands alone. Touch up details that may have been left out during this step.

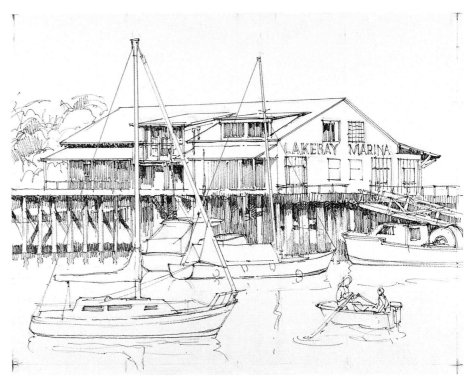

3. Apply the Wash

With a no. 10 round, apply a wash of Burnt Sienna and French Ultramarine to shadow areas below the roof edges and under the dock. This wash should remain somewhat transparent so you can add more layers of color later.

For the sail cover, use a wash of French Ultramarine and Raw Sienna. For the tarpaulins, use Raw Sienna with touches of Hansa Yellow. To darken the background, use a mixture of Burnt Sienna and French Ultramarine.

Lightly paint the boat hulls with a thin wash of Burnt Sienna and French Ultramarine. Leave the paper bare in some areas for the brightest highlights.

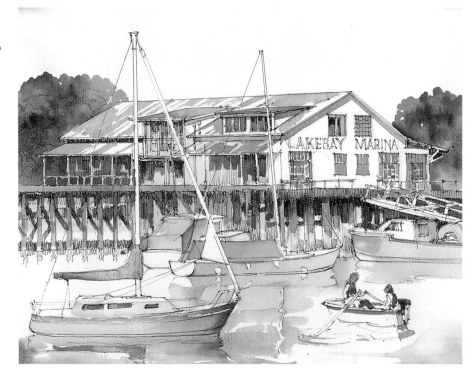

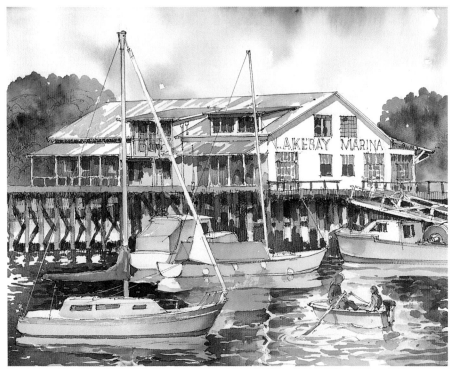

4. Refine the Forms

With a no. 10 round, intensify the shadow underneath the dock by adding more of the Burnt Sienna and French Ultramarine mixture. With this same color, darken the reflection of the boat to the left side of the sail and around the boats and yellow tarpaulins. Darken some of the shadows underneath the dock with a black marker.

Using no. 0 rigger, apply gouache to the masts of the two boats to the left side and to the furled foresail. This is necessary because surrounding washes may run slightly over the edges of these important features. Paint the sail a slightly grayed white. For the masts, apply a mixture of Burnt Sienna and French Ultramarine.

Use the rigger to apply white gouache to those parts of the rigging lines that you drew in ink but since have been obscured by color washes.

With a no. 10 round, apply a little Alizarin Crimson, Hansa Yellow and Burnt Orange to liven up the colors on the building roof, the figures in the rowboat, the yellow tarpaulins and other details.

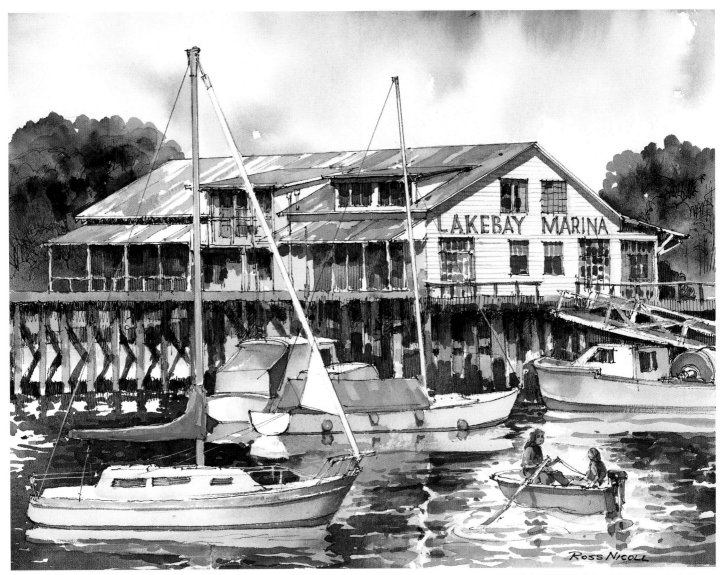

Lakebay Marina, ROSS NICOLL, Waterproof black ink and watercolor on 140-lb. (300gsm) cold-press Arches watercolor paper, 13" × 17" (33cm × 43cm)

5. Finish

Using a 1-inch (25mm) flat, apply a wash of clean water to the sky area. Bring the wash down carefully to the upper edge of the shed's roof, making sure not to wet the tops of the two masts. While this wash is wet, use a no. 10 round to add a few touches of Prussian Blue here and there. While still wet, apply a little French Ultramarine to other parts of the sky for variation. Leave the sky above the roof of the shed blank. While still wet, add a mixture of Burnt Sienna and French Ultramarine to the top edge of the shed. Use this same mixture to create the shadows on the underside of small clouds. Keep in mind that a slightly blotchy sky looks more interesting than a flat wash of color.

After the sky has dried, paint the background trees with a no. 10 round. Apply French Ultramarine and Raw Sienna to the lower parts of the trees. Apply a mixture of Raw Sienna and Prussian Blue to the light green treetops. Add a little Hansa Yellow to liven up the green. For contrast, use the black marker to define the lower parts of the trees. Using the no. 0 rigger, paint the masts' reflections with white gouache, making they shimmer. Paint white gouache to where the oars enter the water. Paint ripples with Burnt Sienna and French Ultramarine in to show the oars breaking through the water.

Large Boats

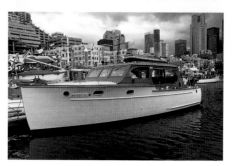

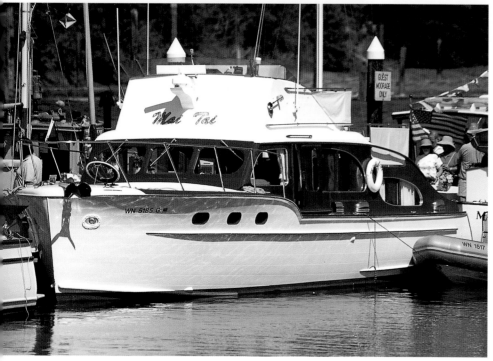

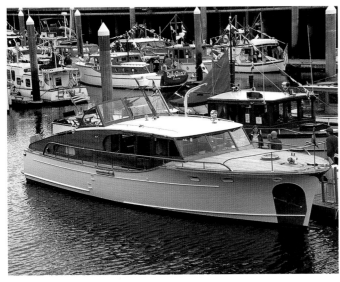

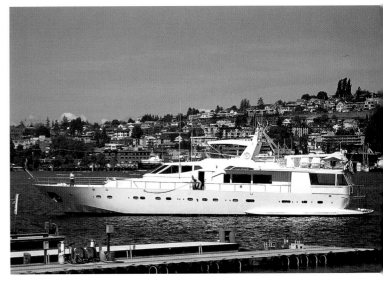

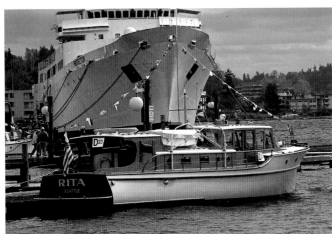

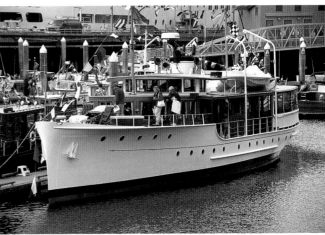

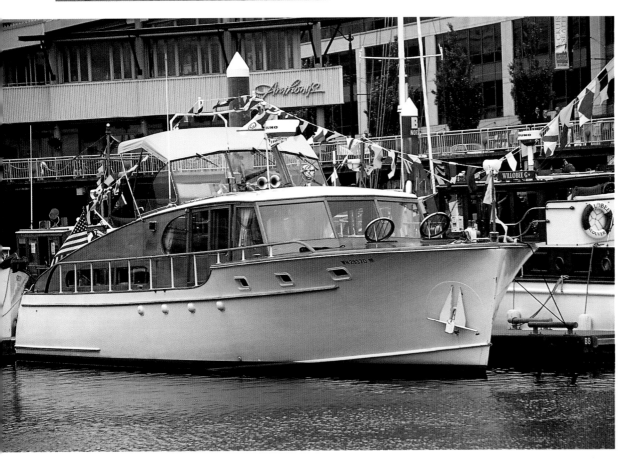

Large Boats

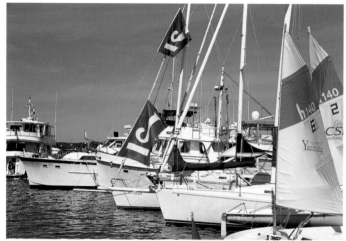

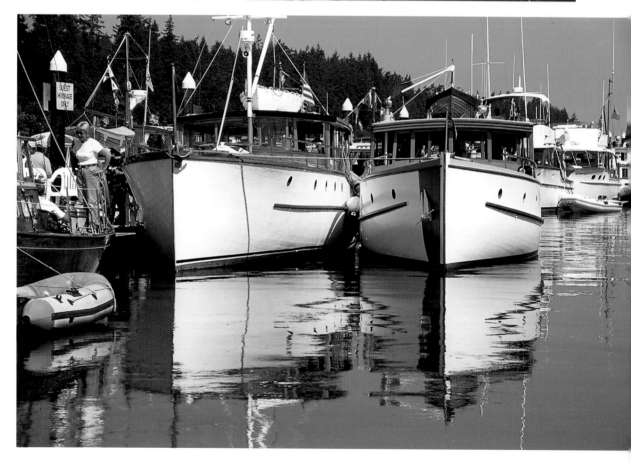

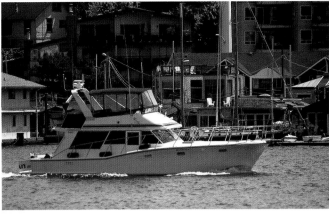

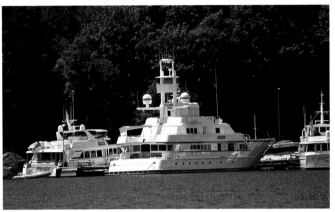

Large Boats

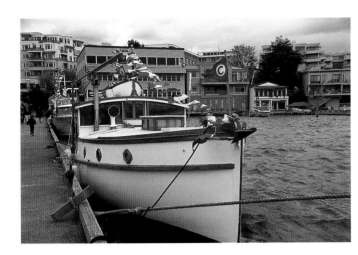

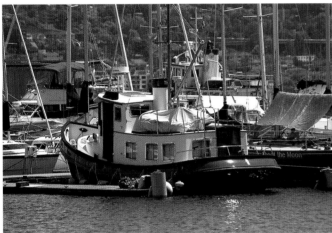

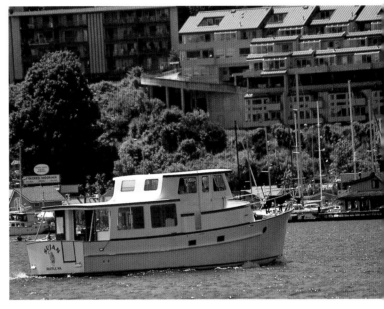

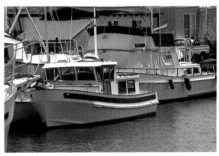

Small Boats

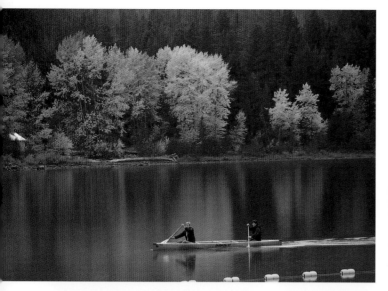

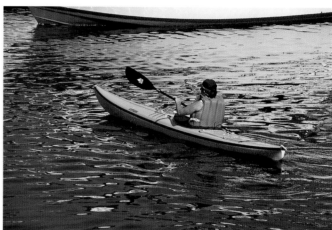

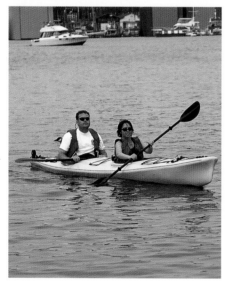

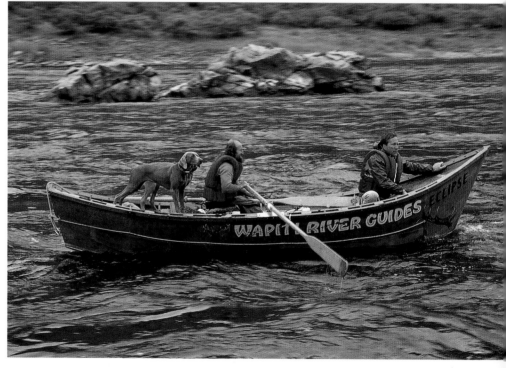

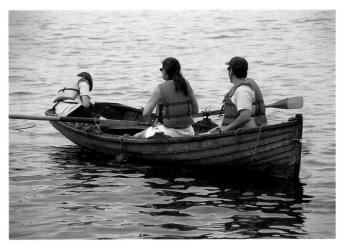

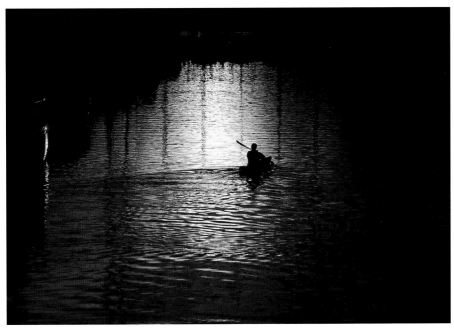

Small Boats

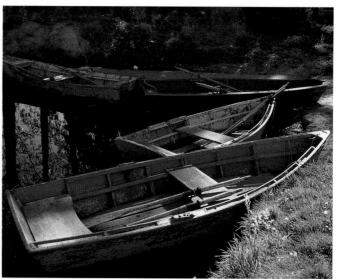

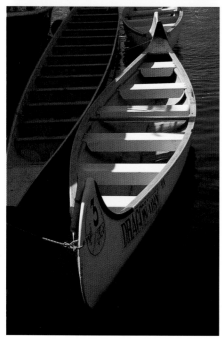

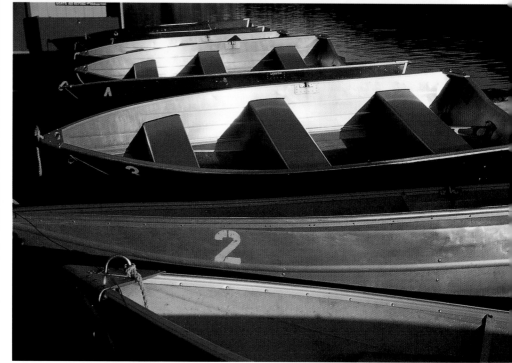

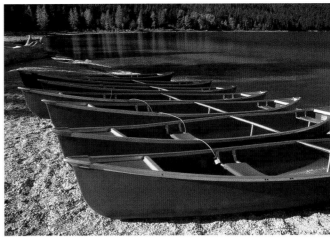

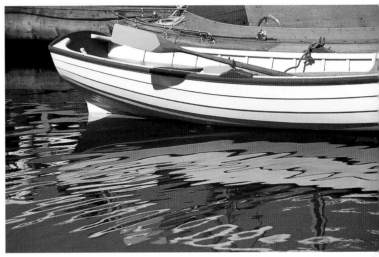

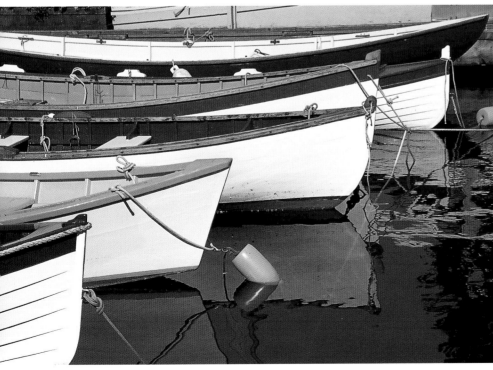

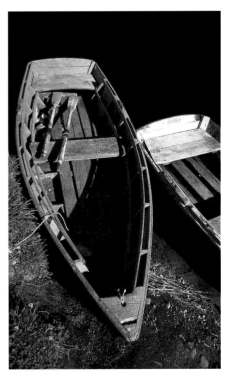

Small Boats

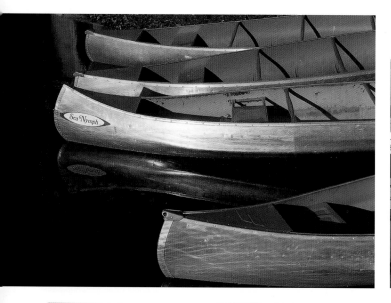

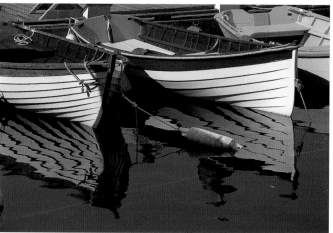

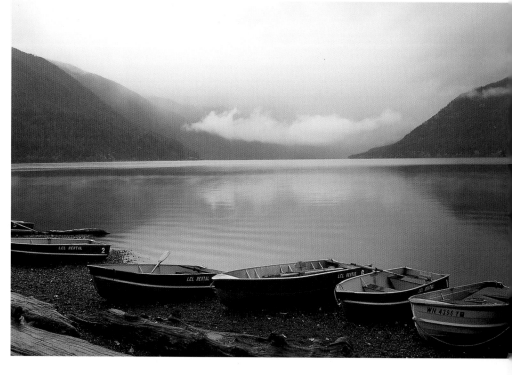

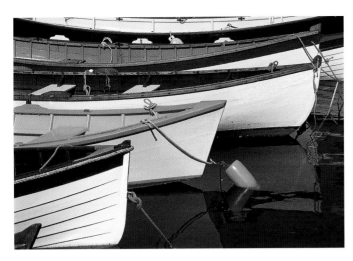

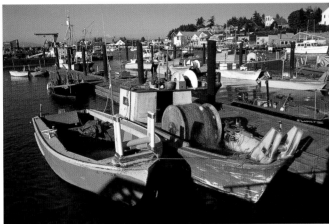

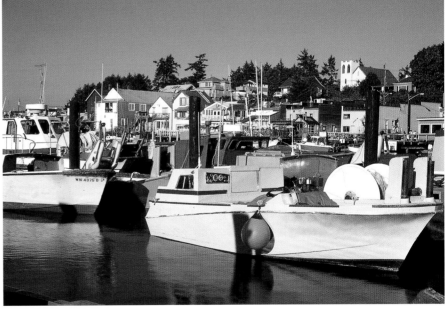

Small Boats

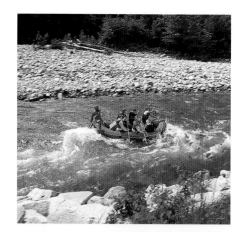

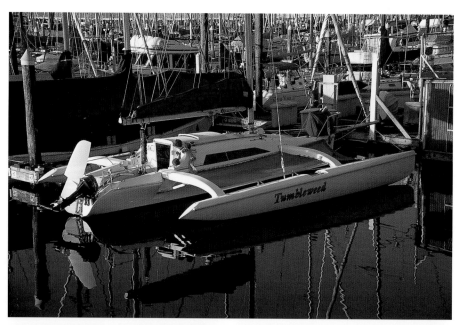

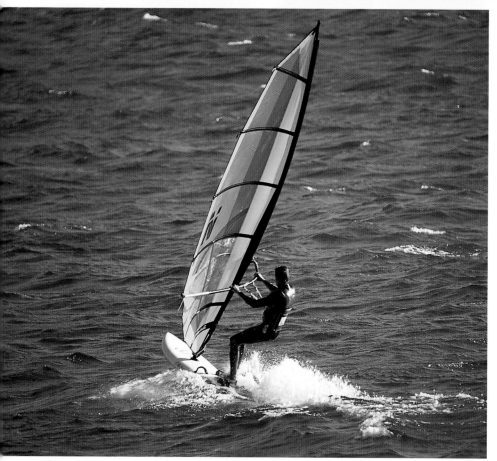

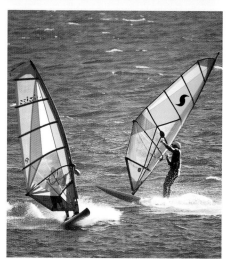

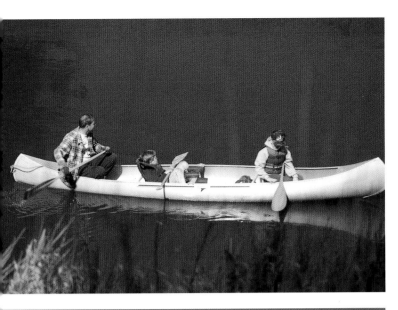

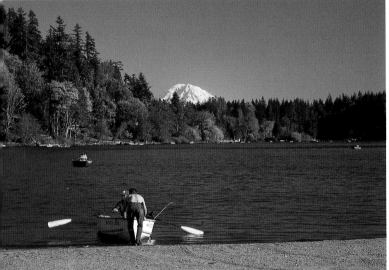

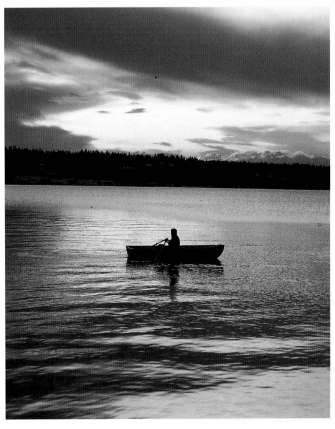

Seaplanes

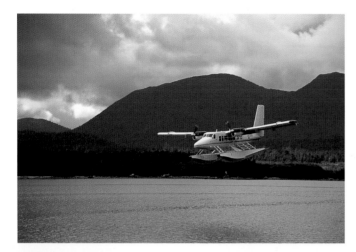

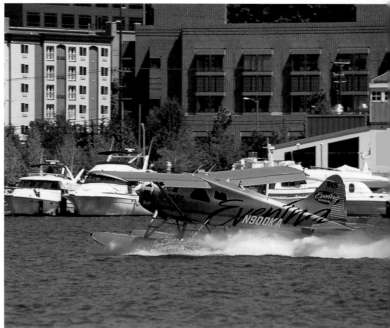

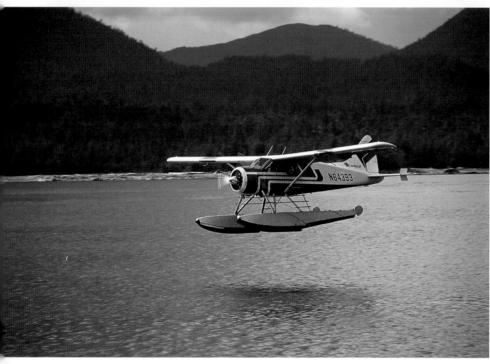

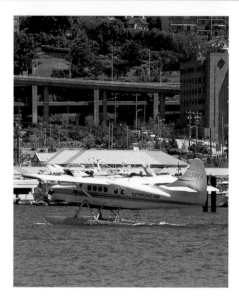

Weathered Boats

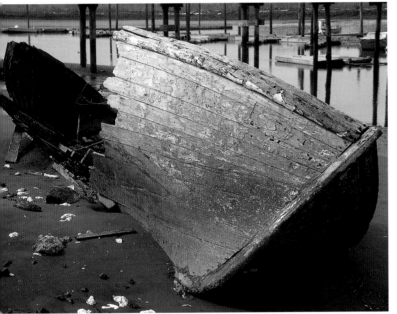

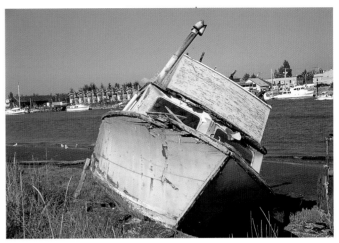

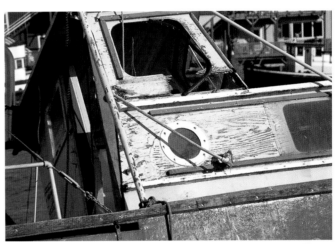

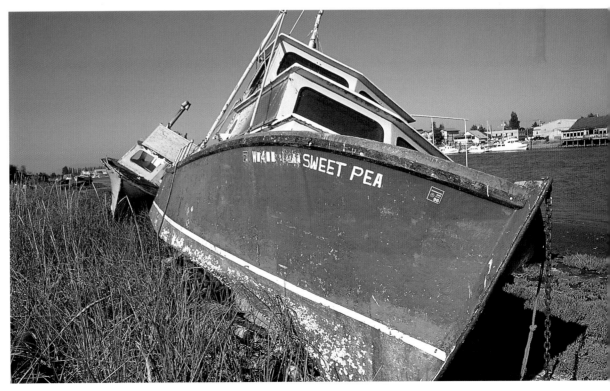

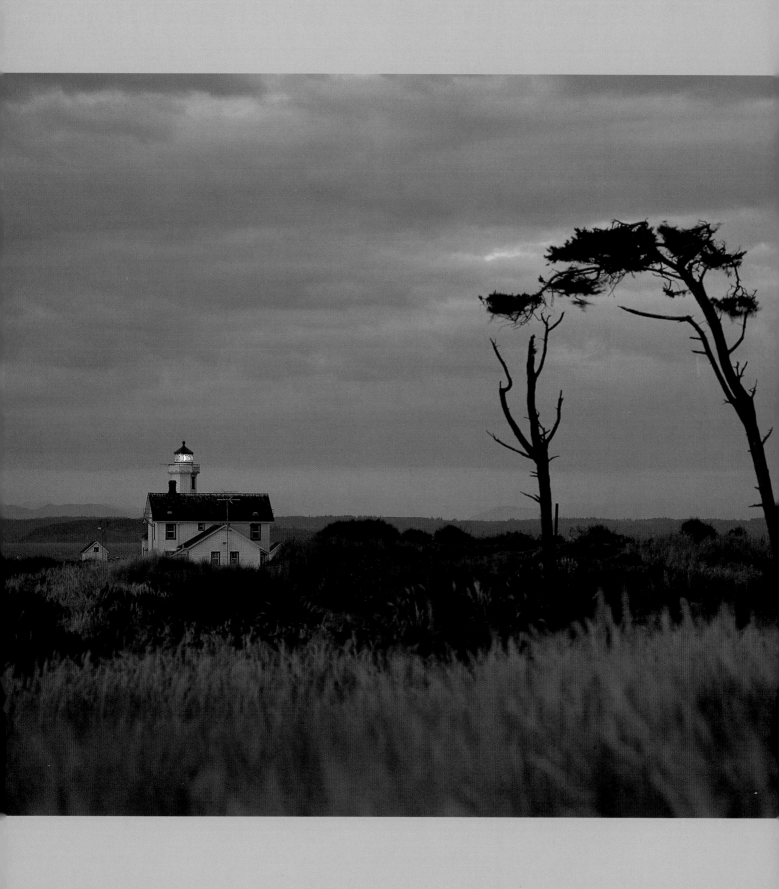

Nautical Scenes

This section features a variety of reference photos. The scenes include seascapes, marinas, harbors, docks, piers and lighthouses. Also included are photographs of nautical objects such as fishing nets, floats, anchor chains, and other things that can be used as subjects or as details. If you take your own reference photos, use these scenes and objects as guides to add to your own photo library.

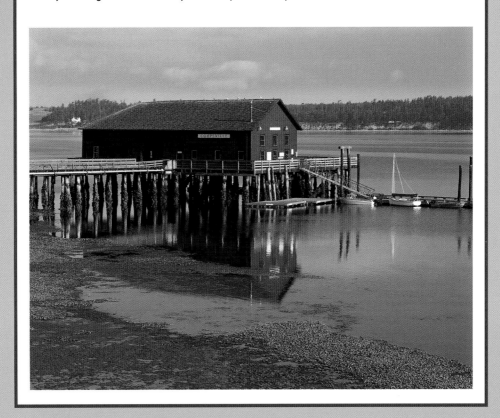

Ports and Bridges

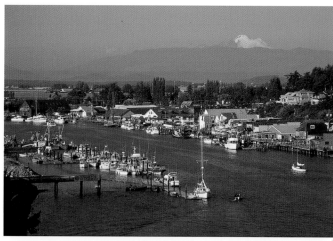

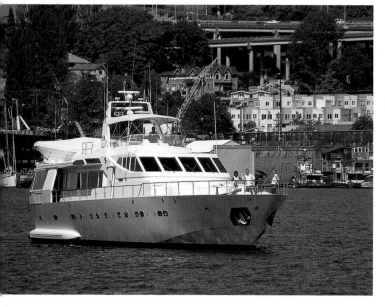

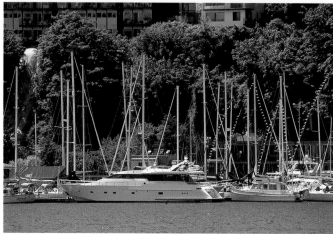

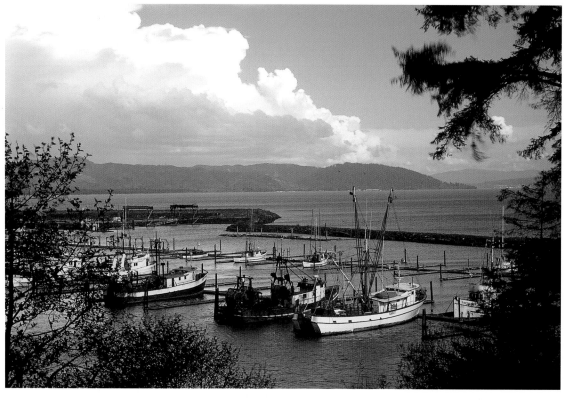

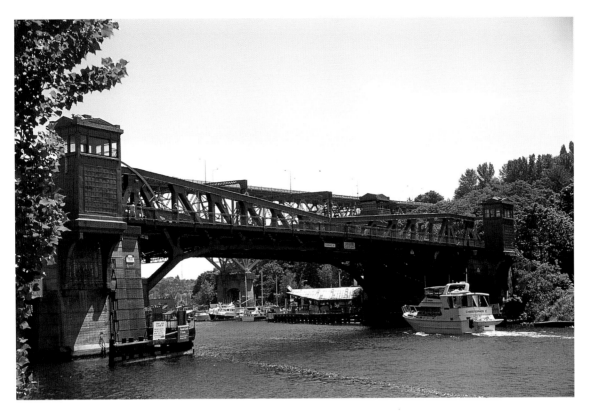

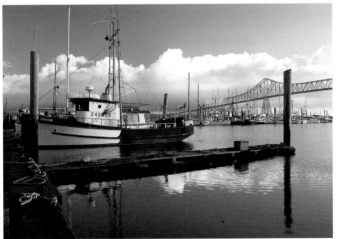

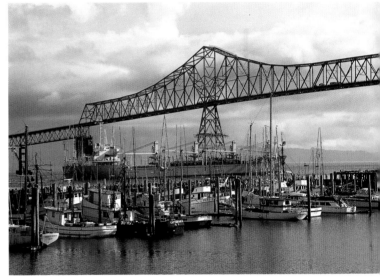

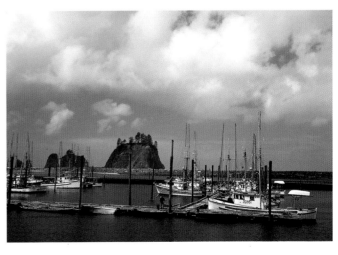

Marinas

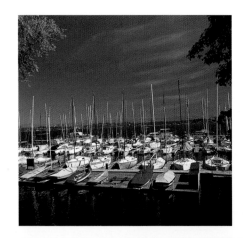

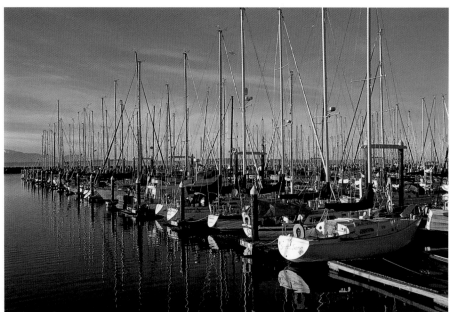

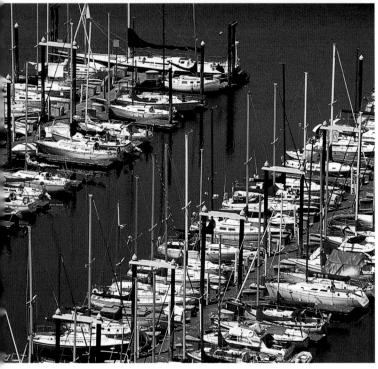

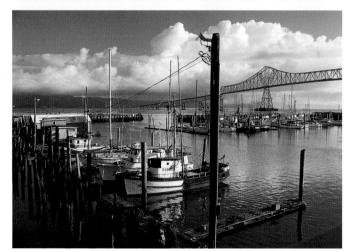

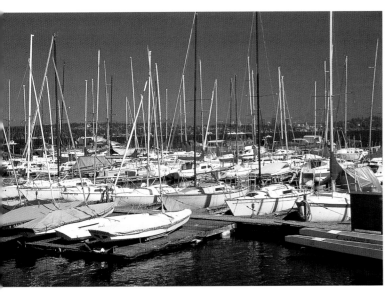

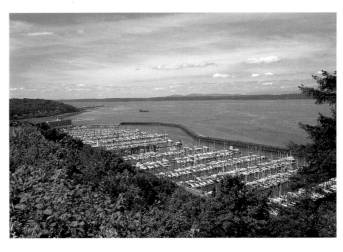

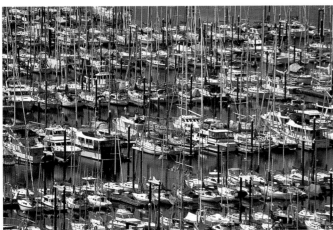

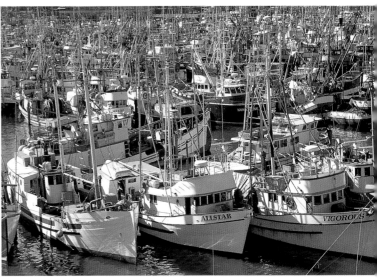

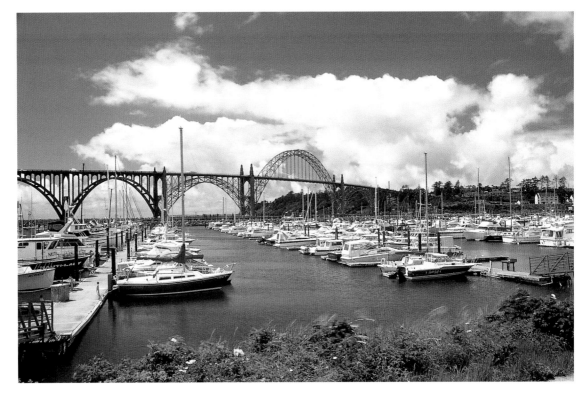

Marinas

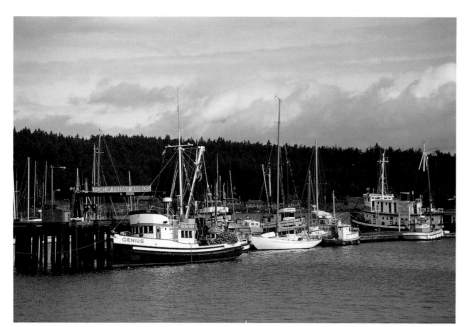

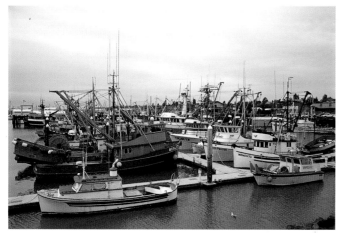

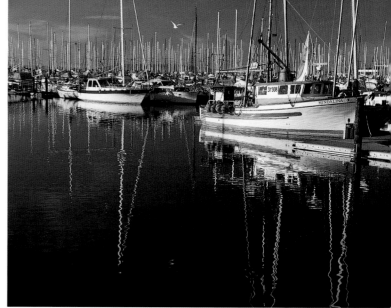

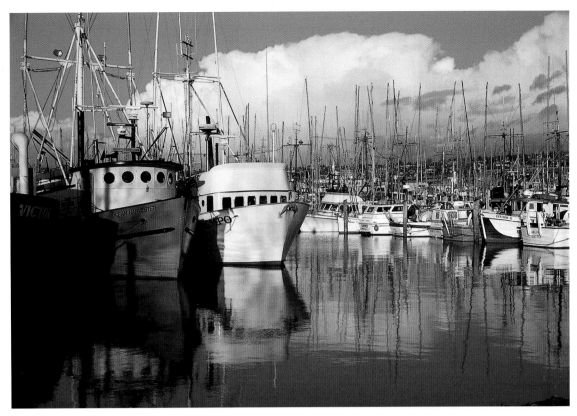

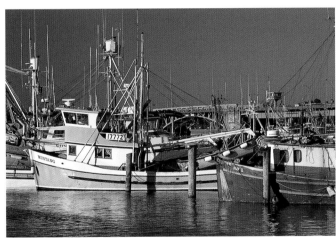

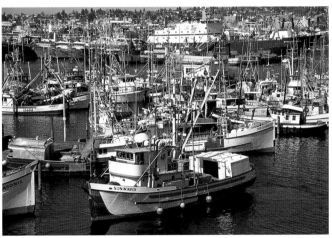

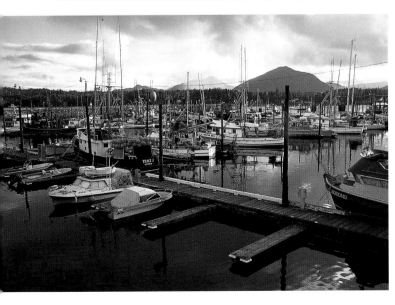

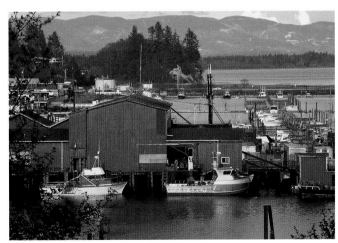

Marinas

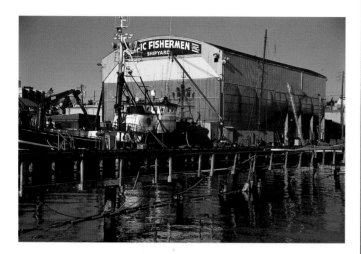

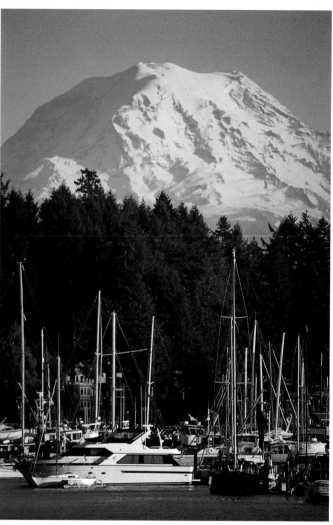

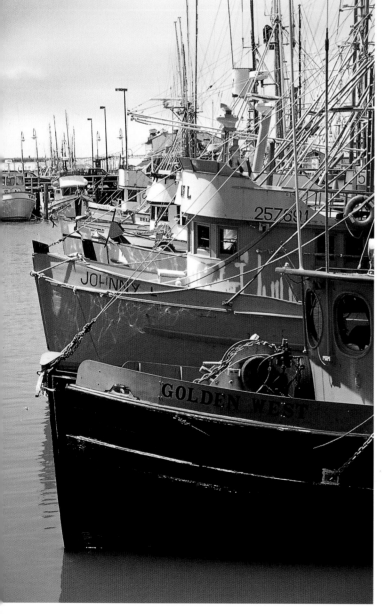

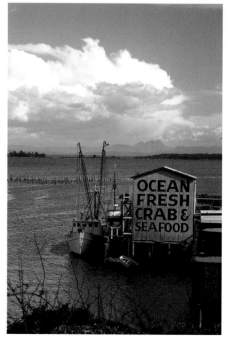

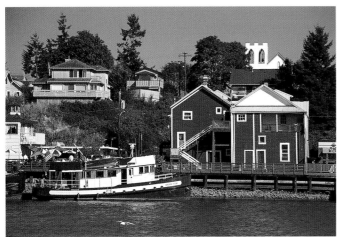

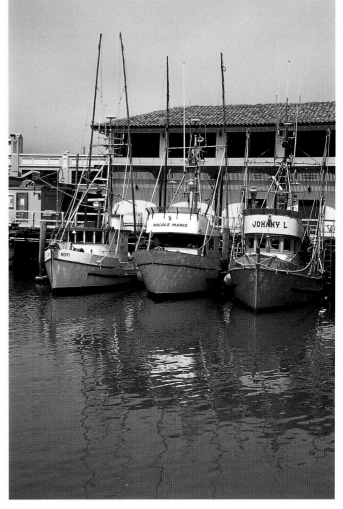

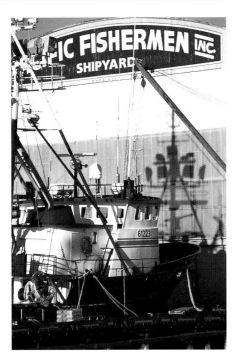

Marinas

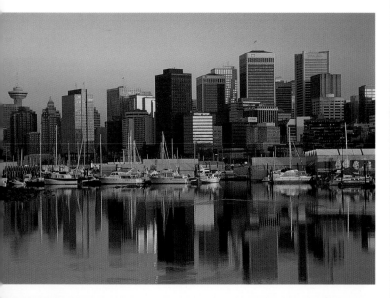

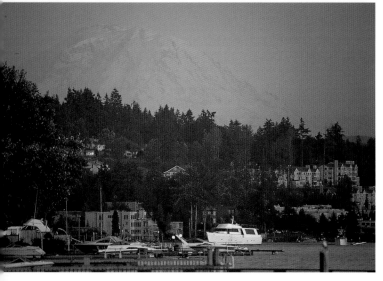

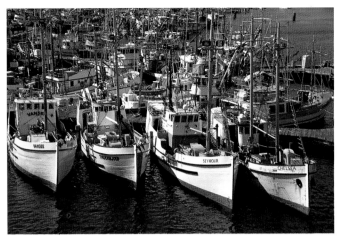

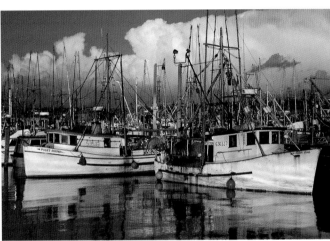

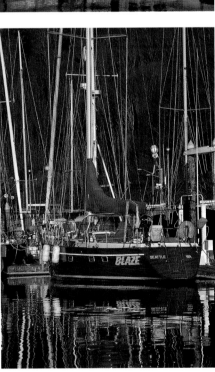

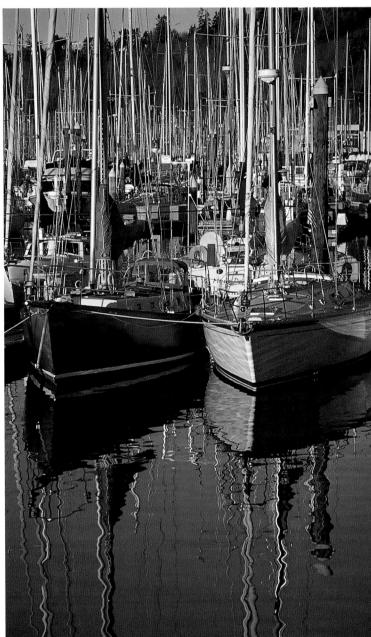

Marinas

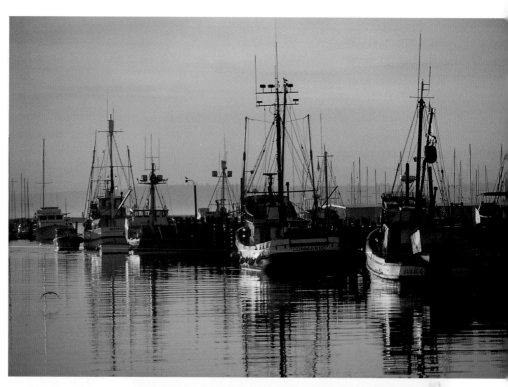

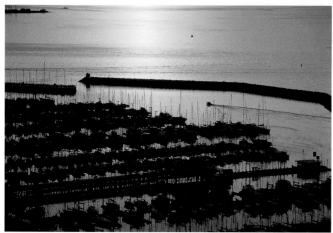

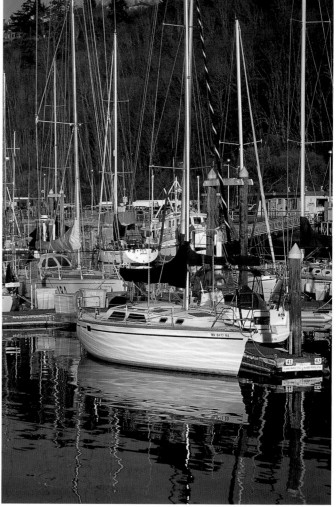

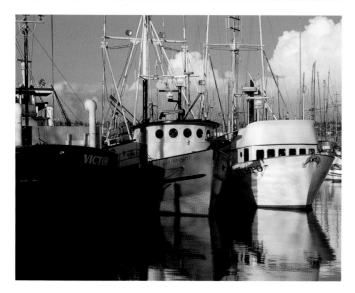

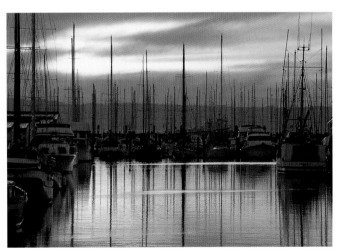

Marinas

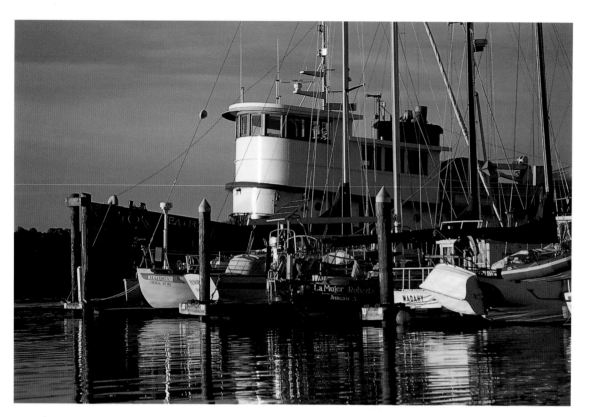

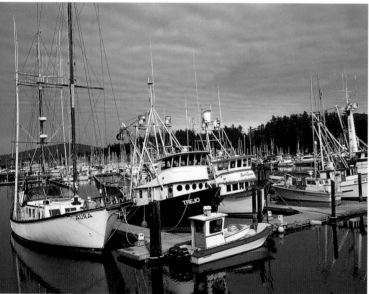

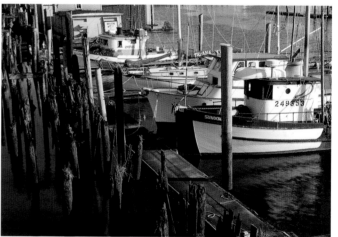

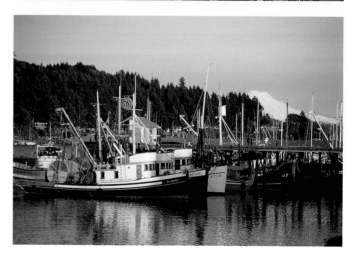

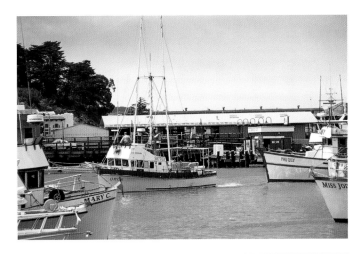

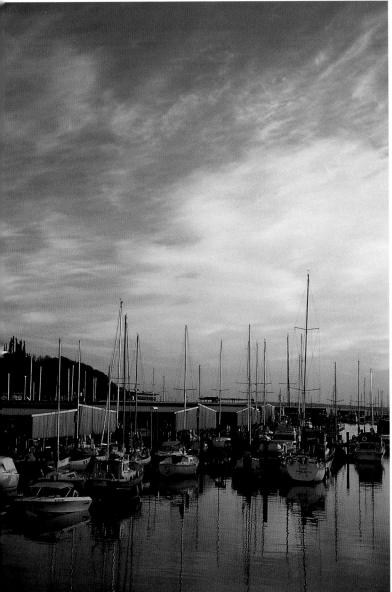

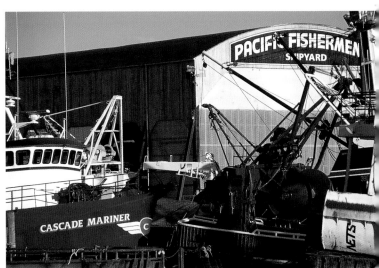

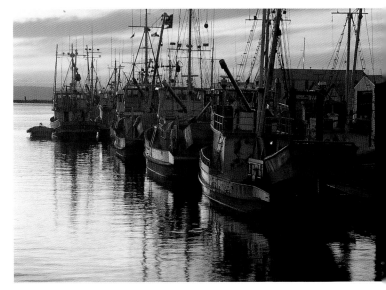

Piers and Docks

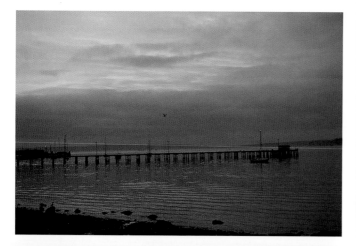

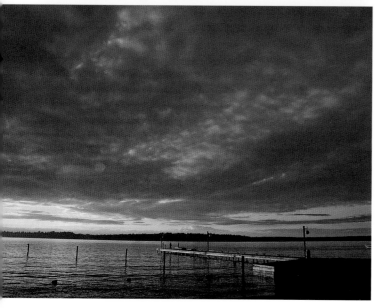

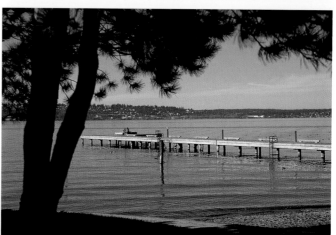

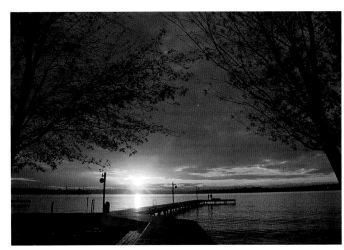

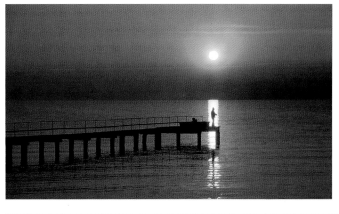

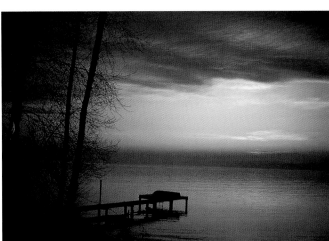

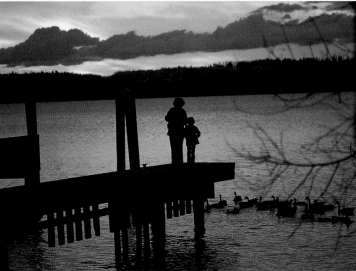

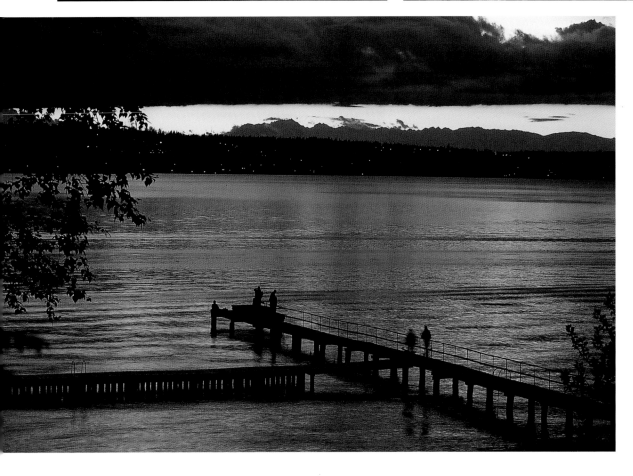

Piers and Docks

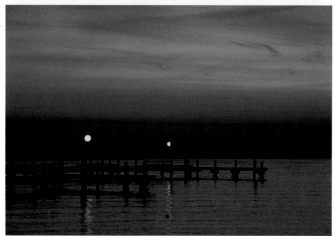

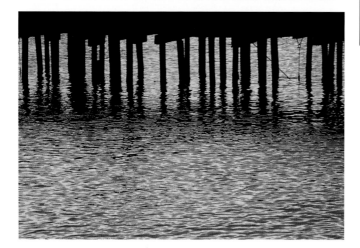

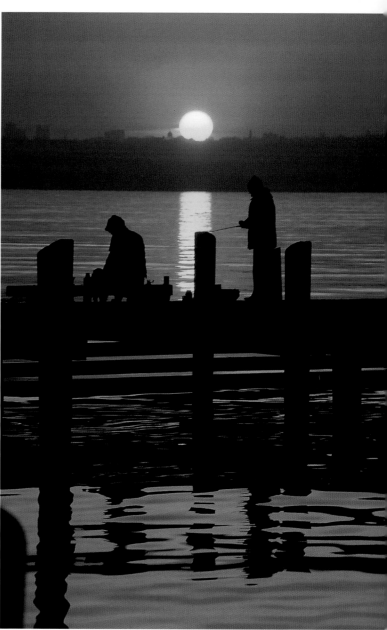

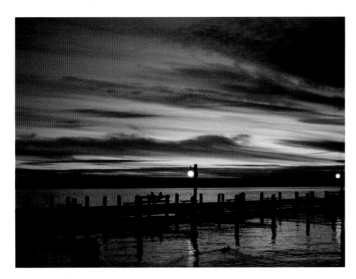

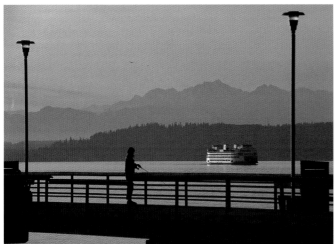

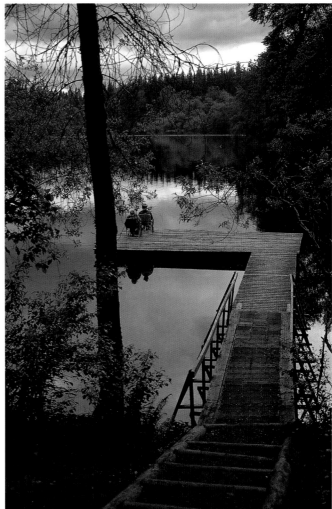

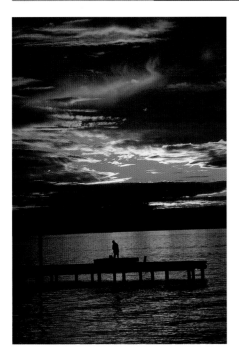

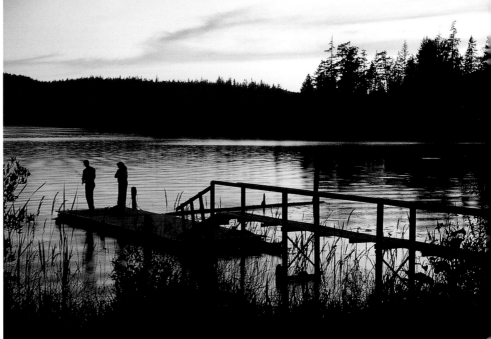

Floats in Colored Pencil

by Gary Greene

Materials

Surface
15" × 23" (38cm × 58cm) Strathmore white 4-ply museum board

Other
2B graphite pencil
Bestine rubber cement thinner
Cotton-tipped applicators
French curve set
Kneaded eraser
Koh-I-Noor imbibed eraser
Krylon workable fixative
Lyra Splender pencil (a pigment-free colored pencil for blending)
Pencil sharpener
Plastic ellipse template
Small, narrow-mouth glass jar with screw-on cap

Color Palette

Faber-Castell Polychromos
Cadmium Yellow, Gold Ochre, Warm Grey II, III, IV, V, VI

Sanford Art-Stix
Canary Yellow

Sanford Prismacolor
Apple Green, Black, Canary Yellow, Crimson Lake, Crimson Red, Dark Green, Dark Umber, Goldenrod, Grass Green, Lemon Yellow, Parrot Green, Poppy Red, Scarlet Lake, Sienna Brown, Sunburst Yellow, True Green, Tuscan Red, Warm Gray 90%, Yellow Ochre

Sanford Verithin
Black, Crimson Red, Poppy Red, Dark Brown, Grass Green, Spanish Orange, Warm Gray 20%

While strolling along a dock in the fishing town of Westport, Washington, these colorful floats immediately caught my eye, and I decided to shoot a few reference photos. Before I began to paint this scene, I felt that cropping the extraneous portions of the original photo and making a few adjustments would strengthen this eye-arresting subject.

After scanning the reference photo in an Adobe Photoshop program, I made a working copy. I cropped the copy and removed the numbers carved on the floats by cutting blank yellow areas adjacent to the numbers and pasting over them. I used an airbrush tool to hide my alterations of the photograph. Using the original photograph, I cut the bottom of the lower float in the center and pasted it into the altered copy. Following the same process, I covered up the distracting background with additional floats that were copied, cut and pasted from adjacent floats. Finally, I simplified the ropes by removing those that distracted from the composition. You can get similar results by photocopying images or desired elements and transferring them with tracing paper.

Evidently, the floats were all yellow to begin with and the fishermen later painted on the red and green stripes for identification. In order to achieve the painted on appearance, I used an underpainting technique described in step 2 of the demonstration.

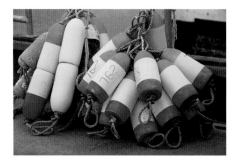

Original Reference Photo

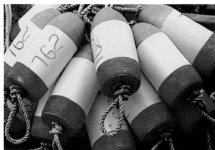

Cropped Reference Photo

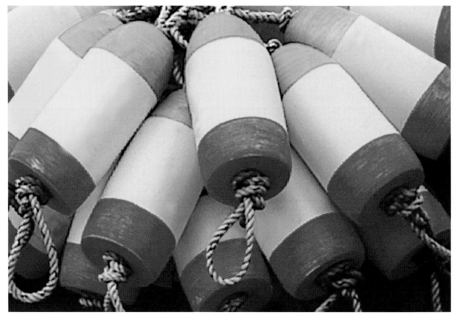

Final Altered Reference Photo

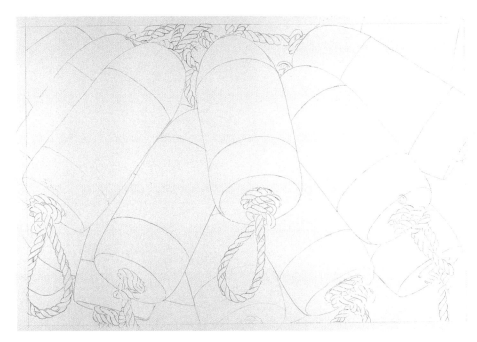

1. Lay Out the Painting

Use a 2B graphite pencil to lay out the painting. Following the ropes, redraw the lines with Warm Grey III. Redraw the floats with Gold Ochre. Use ellipse templates and french curves for accuracy. Remove graphite lines with a kneaded eraser, leaving the colored pencil lines.

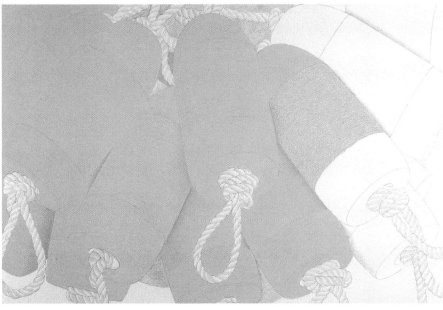

2. Underpainting

Apply Warm Grey II to the darker values of the ropes. Apply Bestine rubber cement thinner with a cotton swab to produce an easily controlled application of color in small areas without streaking. It evaporates quickly and leaves no residue on the paper.

Pour about ¼ ounce (7grams) of Bestine into a small jar with a narrow mouth and cap it immediately to prevent fumes from escaping. When ready to use, loosen the cap, dip the applicator into the Bestine and immediately replace the cap. To avoid skin contact, use cotton swabs with long wood handles. Work in a ventilated area and keep Bestine away from flames. Unlike turpentine and similar solvents, Bestine does not leave a lingering odor.

Apply Warm Grey III to background areas and on the darker values of the floats. Apply Bestine rubber cement thinner with a cotton swab.

Use strokes that follow the cylindrical shape of the floats. Apply Canary Yellow Art Stix and Cadmium Yellow Poly-chromos to the yellow floats.

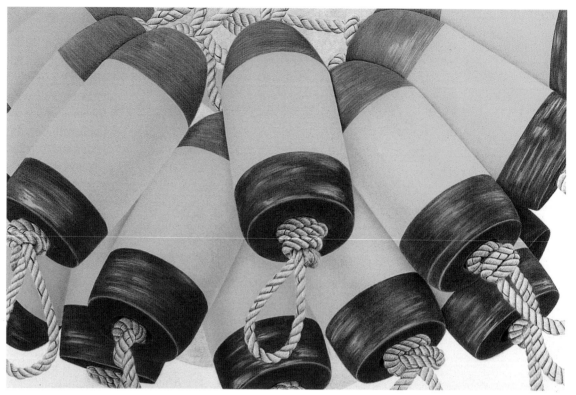

3. Paint the Ropes and Floats

For this step, use a well-sharpened pencil at all times. With Warm Grey V or VI, apply short, linear pencil strokes to one side of the ropes and perpendicular to the twists. Apply longer linear strokes with Warm Grey III, creating roundness by layering color gradually to areas that are highlighted. Layering is the most common technique with colored pencils so use light pencil pressure. Start with the darkest colors first to create complex hues, values and gradations. Darken the creases of the ropes using Warm Grey III. Apply Warm Grey VI to darkest areas.

In the yellow areas of the floats, erase the highlighted areas with a kneaded eraser. Layer Warm Grey IV onto the shadows only. Use Goldenrod, Gold Ochre, Yellow Ochre and Sunburst Yellow following the curves of the floats in the underpainting. If colors become too dark, adjust by adding lighter colors. Gradually layer in Cadmium Yellow, Canary Yellow and Lemon Yellow over the darker values and into erased areas. Touch up the darkest values with Sunburst Yellow, midvalues with Cadmium Yellow and for lightest values with Lemon Yellow. Repeat until the surface is completely covered. Burnish with a Lyra Splender or clean blending pencil. Burnishing involves layering then blending the colored pencil together until the entire paper surface is covered. Apply color lightly, layering lighter colors on top of darker colors.

For the darkest green areas, use Dark Green and Grass Green. Layer Parrot Green, True Green and Apple Green over the entire green area, including the dark values. Burnish with the blending pencil, dragging color into some of the yellow areas. Apply True Green and Apple Green in touches to the yellow area. Again, burnish newly added colors with a blending pencil.

For the top of the float, use Crimson Lake for the darkest values. Layer Crimson Red, Scarlet Lake and Poppy Red over the entire red area, including dark values. Burnish the entire area with the blending pencil, again dragging more color into portions of the yellow areas. Add touches of Scarlet Lake and Poppy Red and continue to blend. For the bottom of the float, layer in Tuscan Red, Crimson Lake and Crimson Red. Burnish these colors using Scarlet Lake and Poppy Red; finish by blending with Crimson Lake.

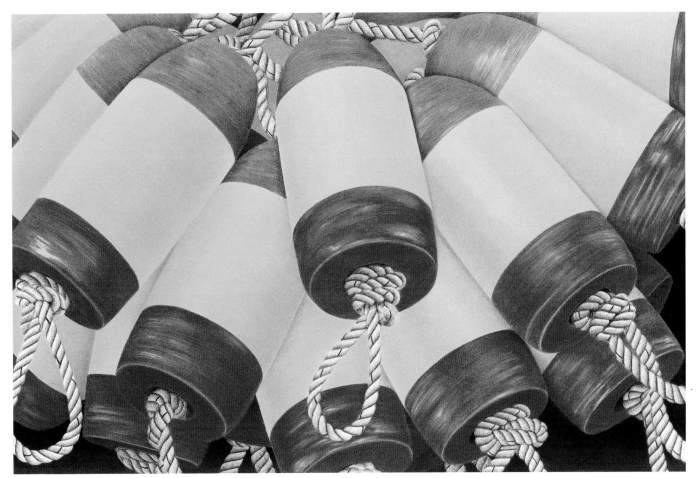

Floats, GARY GREENE, Colored pencil on Strathmore white
4-ply museum board, 15" × 23" (38cm × 58cm)

4. Finish the Floats

To finish the floats, lightly layer Warm Grey IV, Goldenrod, Yellow Ochre and
Cadmium Yellow onto the yellow areas. Next, burnish this area with the blending
pencil. Repeat this process until the entire section is covered. Lightly layer Warm
Grey IV, Grass Green, Dark Green and True Green onto the green areas. Using the
blending pencil, burnish this section.

Lightly layer in Warm Grey IV, Tuscan Red, Crimson Lake and Scarlet Lake to the
red areas. Again, use the blending pencil to burnish this area. In a gradation, layer
Black, Warm Gray 90%, Dark Umber and Sienna Brown. Lightly burnish with the
blending pencil. Repeat as necessary until the entire paper surface is covered. For
the finishing touches, clean up any rough edges with Black, Crimson Red, Poppy
Red, Dark Brown, Grass Green, Spanish Orange or Warm Gray 20% Verithin pencils.

For the background area at the bottom, layer a gradation of Black, Warm Gray
90%, Dark Umber and Sienna Brown. Lightly burnish with the blending pencil.
Repeat as necessary until the entire paper surface is covered.

Floats and Nets

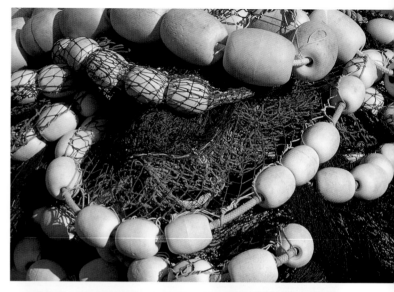

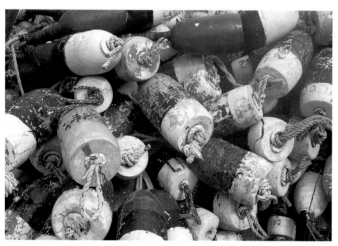

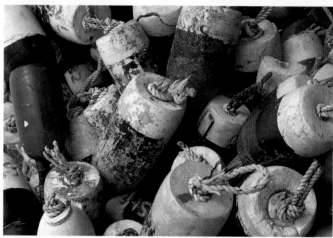

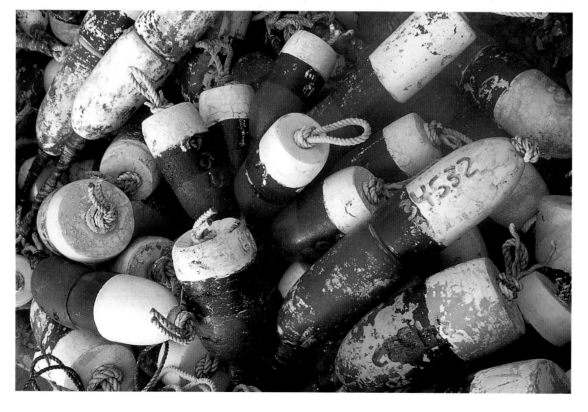

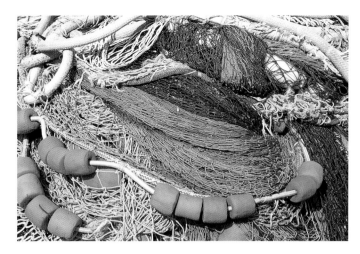

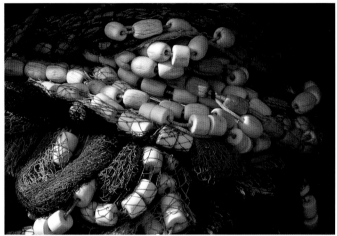

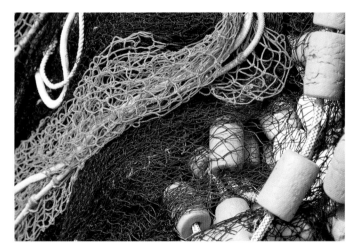

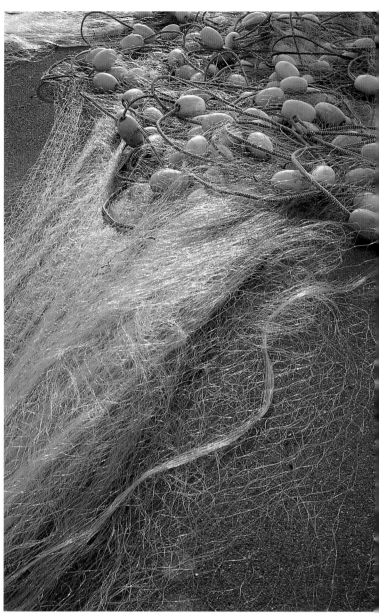

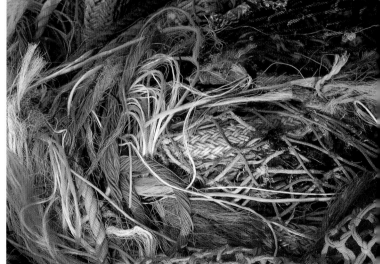

Floats and Nets

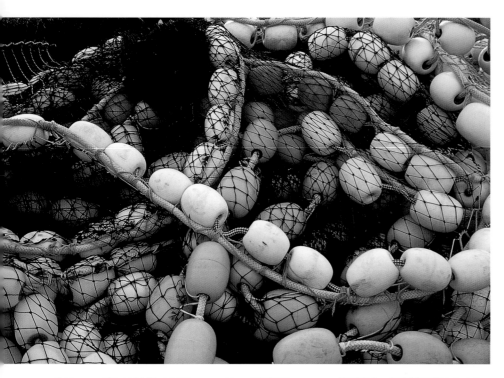

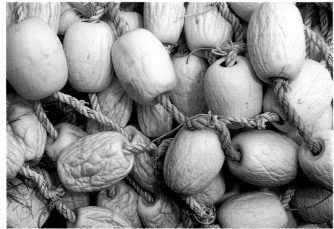

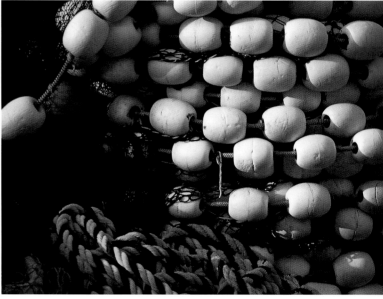

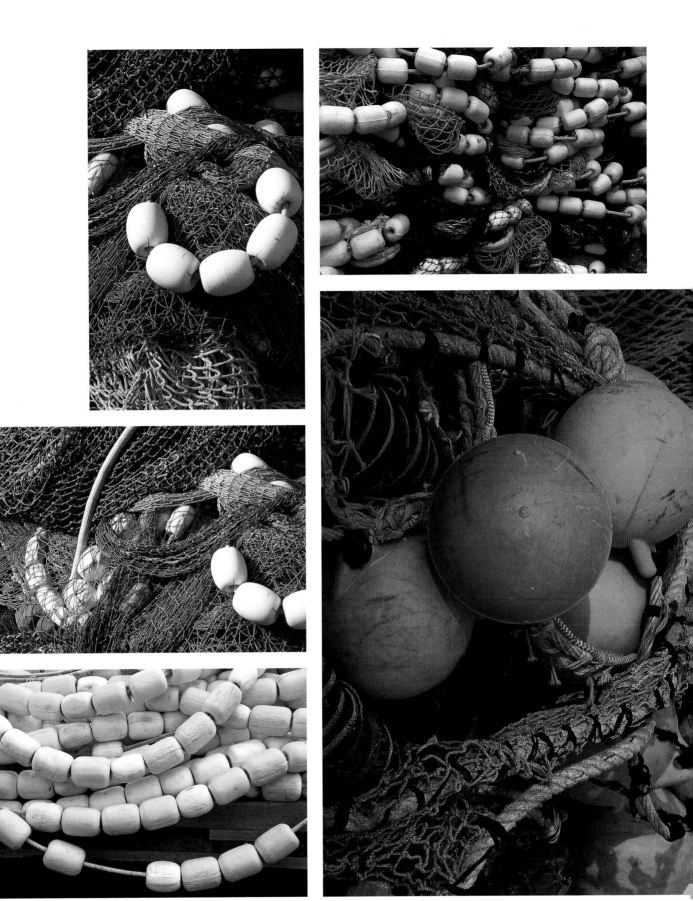

Ropes and Anchors

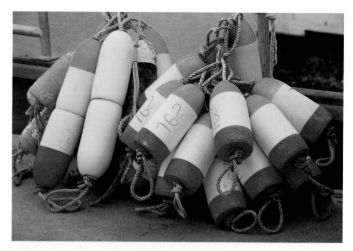

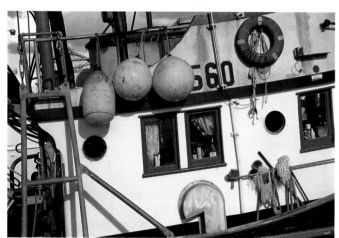

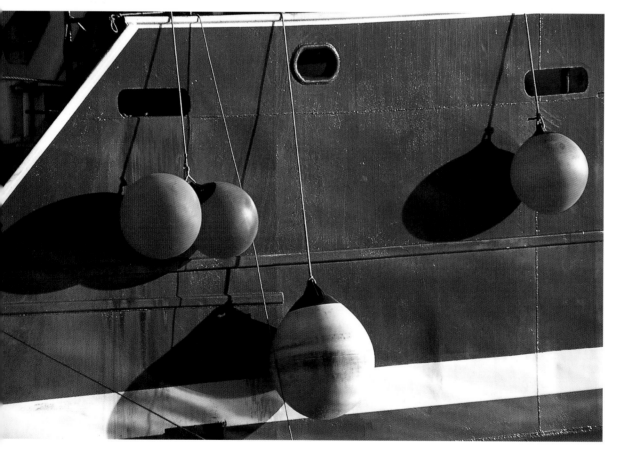

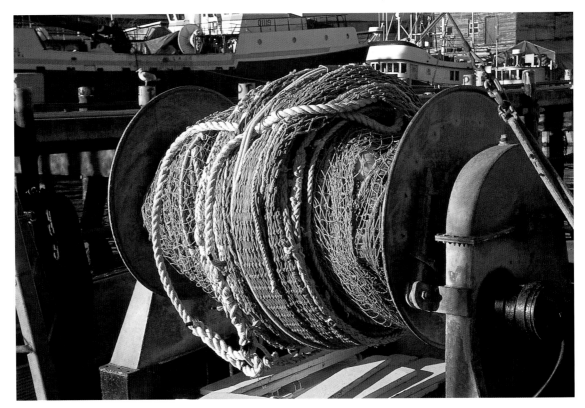

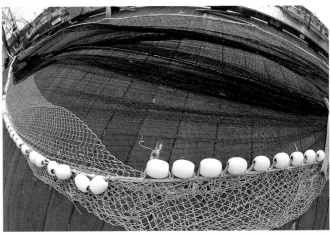

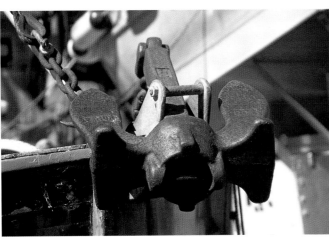

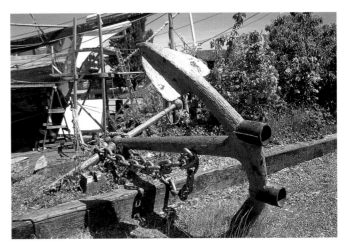

Seagulls

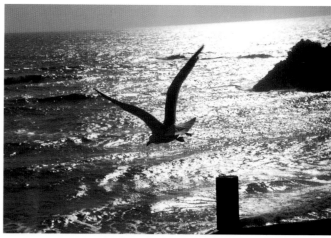

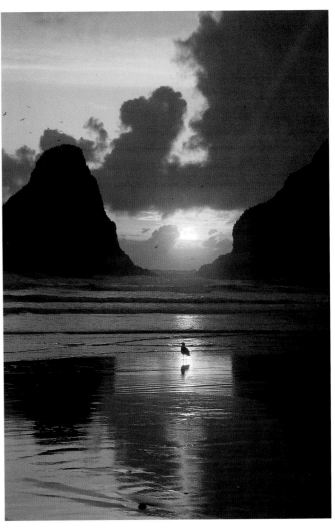

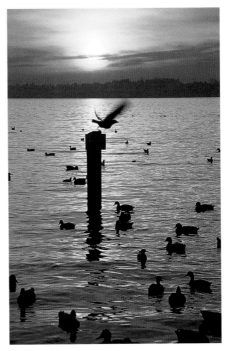

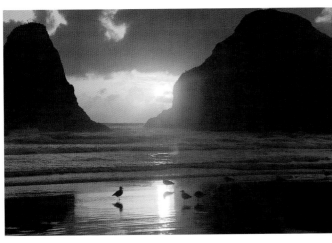

Four Pelicans in Pastel

Materials

Surface
30" × 44" (76cm × 112cm)
100% cotton fiber drafting vellum
30" × 44" (76cm × 112cm)
100% rag vellum finish white paper

Other
30" × 44" (76cm × 112cm) drawing board or masonite
Artist's low-tack tape
Craft knife with no. 11 blade
Kneaded eraser
Lascaux fixative
No. 2 graphite pencil
Rolls or sheets of clear Frisk film

Color Palette

Rembrandt pastels
Black 700,5; Bluish Grey 727,5; 727,7; Burnt Sienna 411,3; Burnt Umber 409,3; 409,5; 409,8; 409,9; 409,10; Caput Mortuum Red 343,3; Cobalt Blue Ultramarine 512,3; 512,10; Deep Yellow 202,9; 202,10; Gold Ochre 231,3; Green Grey 709,10; Grey 704,7; 704,8; 704,9; 704,10; Mars Violet 538,10; Orange 235,3; Permanent Red Deep 371,3; Permanent Red Light 370,5; Raw Sienna 234,8; Raw Umber 408,3; 408,9; 408,10; Red Violet Deep 547,7; 547,9; Ultramarine Deep 506,3; White 100,5; Yellow Ochre 227,7; 227,9

Schmincke pastels
Black 99 D; Caput Mortuum Deep 024 B; Cobalt Blue Tone 064 B; Cold Green Deep 081 B; Flesh Ochre 016 B; Greenish Blue 065 O; Greenish Grey 093 D; Neutral Grey 098 J; 098 N; 098 O; Olive Ochre Deep 029 O; Permanent Red 1 Pale 042 B; Prussian Blue 066 B; Purple 2 050 M; White 01 D

Derwent Pastel Pencils
Brown Ochre 57 B; 57 F; Burnt Sienna 62 D; Chinese White 72 B; Chocolate 66 B; 66 D; 66 F; Dark Olive 74 D; Dark Violet 25 B; 25 F; Deep Cadmium 6 B; French Grey 70 B; 70 D; 70 H; Green Umber 78 D; Indigo 36 B; Prussian Blue 35 D; Spectrum Blue 32 F; Spectrum Orange 11 B; Terracotta 64 B

Conte Pencils
Burnt Sienna 610; Pierre Noire Black 1710 3B; 1710 H; Sepia 617

This remarkable pastel painting by Norma Auer Adams demonstrates that with a little cropping, a simple reference photo can be transformed into a stunning work of art. Although her process may seem complex, it reveals masterful methods to achieve a successful painting. I shot this picturesque reference photo near La Jolla, California. The comical demeanor of the pelicans is irresistible and provides a great starting point for an interesting painting.

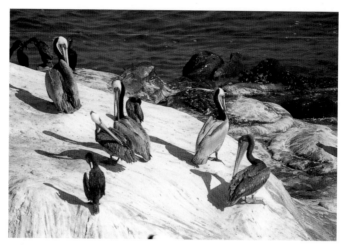

Reference Photo

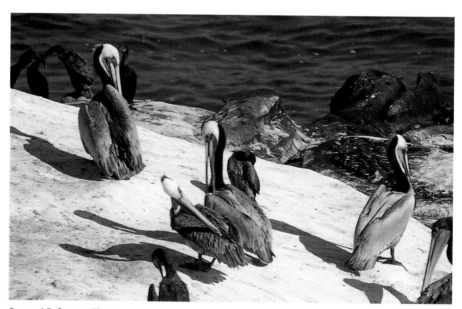

Cropped Reference Photo

1. Lay Out the Painting

Crop the photograph to select a subject. On a piece of drafting vellum, draw the image the same size as the painting, using a no. 2 graphite pencil. During the layout stage, use a kneaded eraser to correct the drawing. Transfer the drawing to a piece of rag vellum by placing the drafting velum underneath the rag velum. Lightly redraw the image. Finish the drawing with a graphite pencil and attach it to a drawing board or piece of masonite with artist's tape, creating a border on all sides. Cover the entire surface with a layer of Frisk film.

2. Paint the Water

To begin laying in the water, cut around the frisked area using a craft knife. Use light pressure when cutting through the Frisk film. Remove the cut piece of film and begin establishing the areas of color.

A For light areas. Apply Rembrandt White, Cobalt Blue, Mars Violet and Red Violet Deep. Apply Schmincke Greenish Blue, White and Purple 2.

B For dark areas. Apply Rembrandt Cobalt Blue and Schmincke Cobalt Blue Tone. After applying pigments, use your fingertips to blend pastels together. Follow the direction of the original pastel strokes.

C Finishing the water. Blend with your fingers, working back and forth between light and dark areas. Use Derwent pastel pencils to define details, blending with the pencil rather than your fingers.

Apply Rembrandt Ultramarine Deep, Schmincke Prussian Blue, Caput Mortuum Deep and Cold Green Deep. Apply Derwent Prussian Blue and Conte in Sepia to the darker areas of the water. For light areas, apply Rembrandt Cobalt Blue and White. Use Derwent Chinese White, Spectrum Blue and Dark Violet.

3. Paint the Background Rocks

A Darkest rocks. Remove the Frisk film from the darkest areas of the rocks to the right. Working on the dark shadows first, apply Rembrandt Black, Grey, Bluish Grey and Schmincke Black, Greenish Grey and Flesh Ochre. Use Derwent Indigo, Dark Olive, French Grey and Conte Sepia, Pierre Noire Black. Reapply the darkest darks and lightest lights after blending.

B Highlighted areas. Apply Rembrandt White, Green Grey, Deep Yellow, Yellow Ochre and Orange. Apply Derwent Brown Ochre and Chinese White.

C Lightest rocks. For the lightest rocks, apply Rembrandt Raw Umber, Burnt Umber, Yellow Ochre, Deep Yellow and Schmincke White. Apply Derwent Green Umber, Chocolate, Deep Cadmium, Spectrum Orange, Dark Violet, Terracotta, Chinese White and French Grey. Finally, apply Conte Sepia.

D Middle values. Remove the Frisk film from the remaining rock areas, leaving the shadow areas. Lay in the details lightly, using Rembrandt Orange, Bluish Grey, Caput Mortuum Red and Raw Sienna. Finish with Rembrandt Deep Yellow, Grey and White. Use Schmincke Neutral Grey, White and Olive Ochre Deep.

E Shadows. Remove the Frisk film from the shadow areas and blend the edges where the shadows and rock meet with Derwent and Rembrandt pastels. Apply Rembrandt Bluish Grey and Red Violet Deep. Use Derwent Brown Ochre, Chinese White and French Grey.

4. Finish the Foreground and Begin the Pelicans

A Remove Frisk film from the rock. Leave the shadow areas untouched. Complete the light areas of the rock before working on the shadows. Underpaint the details lightly with Rembrandt Orange, Bluish Grey, Caput Mortuum Red and Raw Sienna. Finish the rocks with Rembrandt Deep Yellow, Grey and White. Use Schmincke Neutral Grey, White and Olive Ochre Deep.

B Shadows. Remove the Frisk film from the shadow areas and complete the rocks. Blend the edges where shadows and rock meet with pastel pencils. Apply Rembrandt Bluish Grey and Red Violet Deep. Next, apply Derwent Brown Ochre, Chinese White and French Grey.

C Center the birds. Remove the Frisk film from the birds one at a time. Complete the light areas of the birds by applying Rembrandt Deep Yellow, Permanent Red Deep, Burnt Umber, Gold Ochre, Black, Burnt Sienna and Raw Sienna. Next, apply Schmincke Black and Derwent Brown Ochre and Chocolate.

D Bodies. Apply pastels listed above to the heads of the center birds. Apply Rembrandt Permanent Red Deep, Burnt Umber, Burnt Sienna and Black. To finish the bodies, apply Derwent Terracotta and Burnt Sienna.

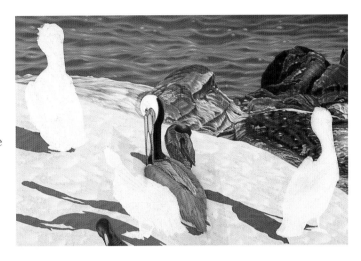

E Heads. To the light areas, apply Rembrandt Burnt Umber, White and Deep Yellow. Use Schmincke Olive Ochre Deep and White. Finally, apply Derwent French Grey and Chocolate.

F Eyes. Apply Derwent French Grey, Brown Ochre and Chinese White. Next, use Conte Sepia and Black.

G Bills. Apply Rembrandt Permanent Red Deep, Permanent Red Light, Raw Sienna, Deep Yellow, Grey and Burnt Umber. To finish the bills, apply Schmincke Permanent Red 1 Pale and Neutral Grey. Finally, use Derwent Chocolate and Deep Cadmium.

5. Finish
Spray with fixative when the drawing is finished. Spray the surface in a well-ventilated area. Remove the artist's tape from around the edges of the painting.

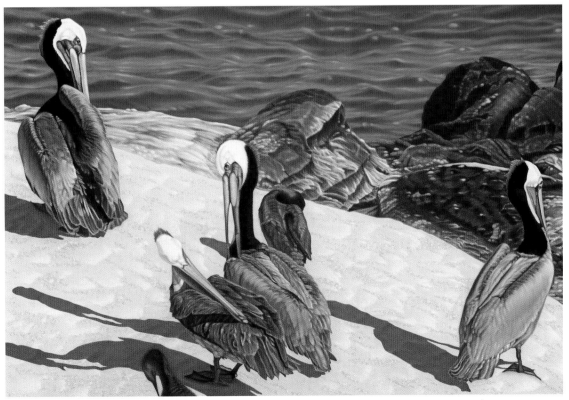

Four Pelicans, NORMA AUER ADAMS, Pastel on rag vellum, 28" × 42" (71cm × 107cm)

Lighthouses

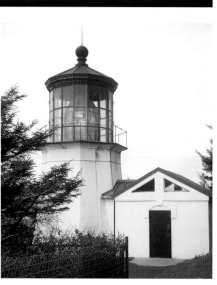

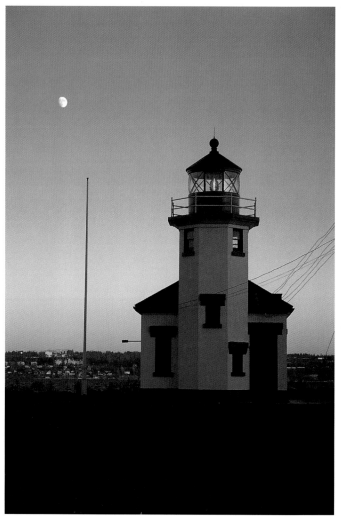

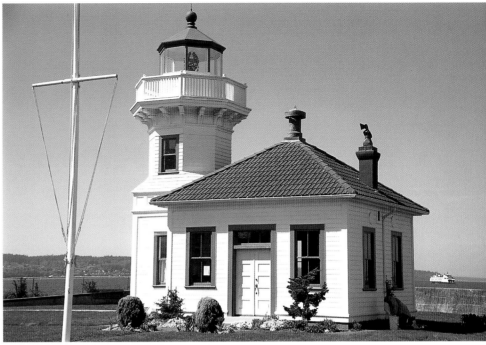
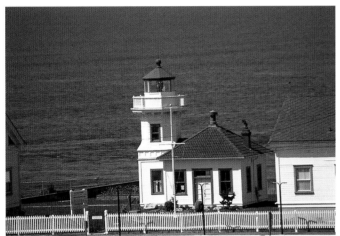
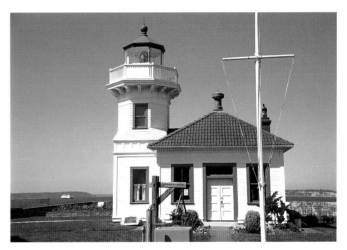
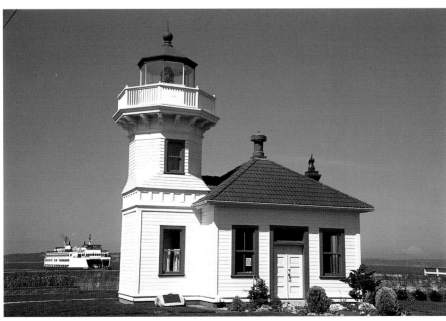

Lighthouses

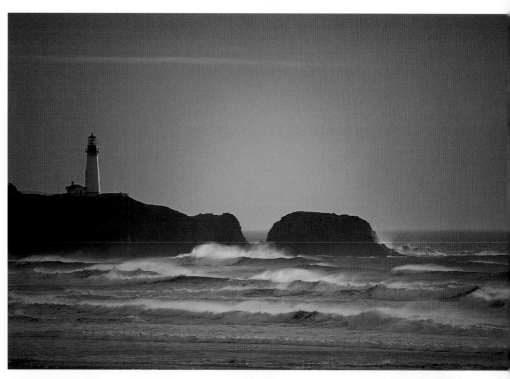

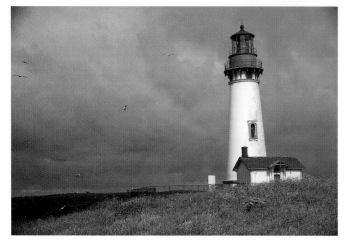

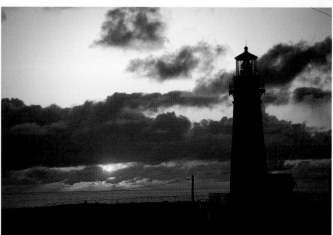

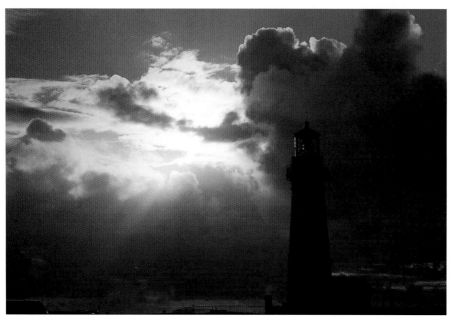

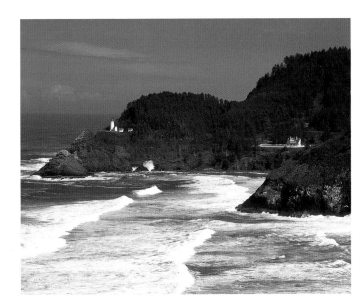

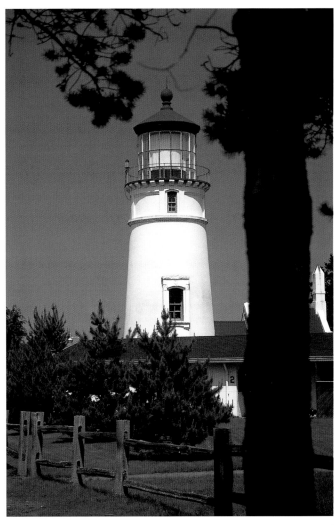

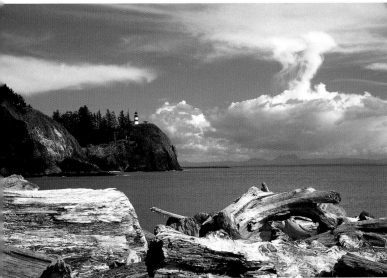

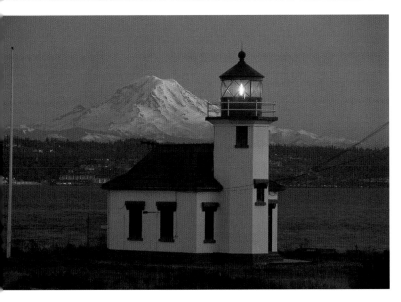

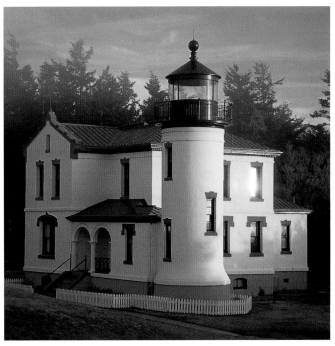

Lighthouse at Sunrise in Acrylic

Materials

Surface
21" × 27" (53cm × 69cm) watercolor board

Brushes
No. 16 synthetic bright
No. 6 flat mixed synthetic
No. 6 round mixed synthetic
2-inch (51mm) synthetic flat
Old 3-inch (76mm) house brush

Other
11" × 15" (28cm × 38cm) metal Chinese butcher tray palette
Masterson's large Sta-Wet palette paper refills
Paper towels
Spray bottle and water container
Utrecht professional gesso or Golden acrylic molding paste

Color Palette

Golden Fluid acrylics
Dioxazine Purple, Quinacridone Gold

Golden Heavy Body acrylics
Anthraquinone Blue, Cadmium Orange, Cadmium Red Light, Cadmium Yellow Light, Quinacridone Red Medium, Titanium White

The two images used in this demonstration depict how reference photos from vastly different locales can be combined to create an exciting painting. The primary reference photo of Oregon's Yaquina lighthouse was shot on a blustery spring evening. The weather did not cooperate, resulting in a poorly lit and uninteresting scene. Nevertheless, I made the photo and stored it with similar images.

I selected the photo of a sunrise at Onealli Beach in Molokai because of its atmospheric excitement and spectacular sky. I thought it would be much easier to crop out the landscape elements later. After scanning both images using Adobe Photoshop, I combined them by superimposing the sunrise photo over the lighthouse image. After deleting unwanted elements, I lightened the opacity of the sunrise and merged the two layers. The images can also be combined by using photocopied images and tracing paper. With a bit of imagination, you can compose an effective composite photo by hand.

Dyanna Shyne added her own interpretation to the composition by making the lighthouse smaller than it is in the reference photo. In order to give the landscape a greater presence, she lengthened the lighthouse tower and added a light. The lighting in the painting was changed to reflect conditions of an Oregon sky in spring.

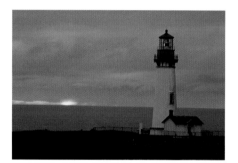
Original Reference Photo

Reference Photo 2

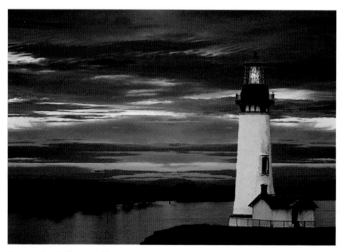
Composite Reference Photo

 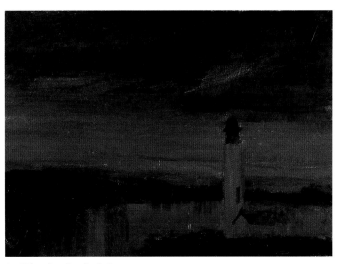

1. Lay Out the Painting

Coat the watercolor board with a layer of gesso or molding paste. Use a 3-inch (76mm) house brush to make brushmarks. Let dry for up to twenty-four hours. Fill a water container and a spray bottle with clean water. Spray the panel with water so it is evenly wet. Squeeze out approximately twelve drops of Quinacridone Gold onto the palette. Dampen a 2-inch (51mm) synthetic flat with water and add water to the Quinacridone Gold until it is drippy.

Apply the paint in horizontal brushstrokes from top to bottom. Work quickly so that the paint does not dry. Dampen a paper towel and remove paint everywhere that the painting will be light in value. Use the same amount of Quinacridone Gold, but this time do not dilute it. Using a 2-inch (51mm) synthetic flat, apply the paint to the panel wherever the painting will be darkest in value. This will serve as the underpainting. Allow it to dry thoroughly.

Clean the palette and line the bottom with a paper towel. Wet the towel completely, squeezing out excess water. Lay a single sheet of acrylic palette paper over the towel and dampen with more water. Smooth the palette paper with your hands until it is flat. This step is very important to insure that the paints do not dry out during the painting session.

Along one side of the palette, squeeze out quarter-sized amounts of acrylic paint in this order: Titanium White, Cadmium Yellow Light, Cadmium Orange, Cadmium Red Light, Quinacridone Red Medium and Anthraquinone Blue.

2. Mix the Dark Colors

Use the center of the palette to mix the dark and middle tones of the painting. For the dark purple color in the painting, mix several drops of Dioxazine Purple with a small amount of Cadmium Red Light. Adjust this color by adding small touches of Anthraquinone Blue or Cadmium Orange until the color becomes a very warm purple.

For the red sky color, combine Cadmium Red Light and Quinacridone Red Medium, adjusting the color until it is a warm red. Again avoid using Titanium White in your mixture. For the lavender color of the lighthouse, use a small amount of the dark red mixture and a dab of Titanium White. Adjust this color with bits of Dioxazine Purple or Cadmium Orange until it is slightly lighter than the land.

Next, dampen the surface with the sprayer. Using the mixtures, paint the areas that represent the dark land formations with the dark purple mixture. Using loose, feathery brushstrokes, paint the sky with the mixture of Cadmium Red Light and Quinacridone Red Medium. Finally, paint in the area that represents the lighthouse with the mixture of lavender.

Drag some of the dark color vertically through the water from the land above and use some of the dark mixture to define details on the lighthouse.

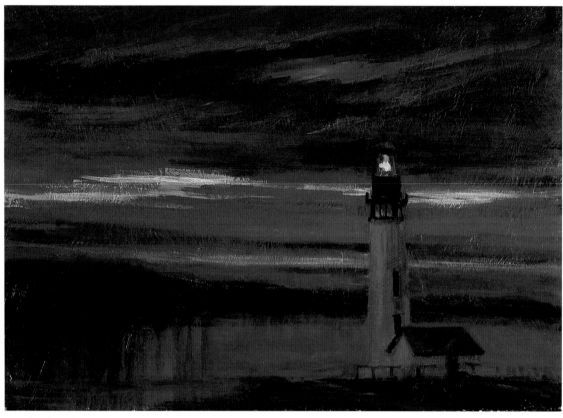

3. Mix the Light Colors

Paint in the sky and highlights on the water by using a small amount of Cadmium Yellow Light mixed with Titanium White. Decide where the lightest part of the sky should be placed and paint this area with the Cadmium Yellow Light. Use a dark purple mixture to redefine the shapes and details of the lighthouse, the small fence and the landscape. Use the no. 6 synthetic flat and round to add details to the ground. To make the shape more interesting, add a narrow brushstroke of red to indicate the light from the sky. Create the shadow of the lighthouse by adding a little of the dark purple mixture to the light purple mixture used to paint the lighthouse. Brush the darker value onto the center and right-hand side of the lighthouse to give roundness.

Use the yellow and white mixture for the light in the lighthouse. Add this detail when the lighthouse is complete and positioned correctly. Load a no. 16 brush with Cadmium Orange and lightly scumble this color onto the horizon directly behind the hills. Use this same color lightly on the underside of the dark clouds for roundness. Wipe off the brush and drag a small amount of the dark through the lower part of the sky. Keep the brushstroke light. If any stroke gets too dark, wipe it away with a damp paper towel before it begins to dry.

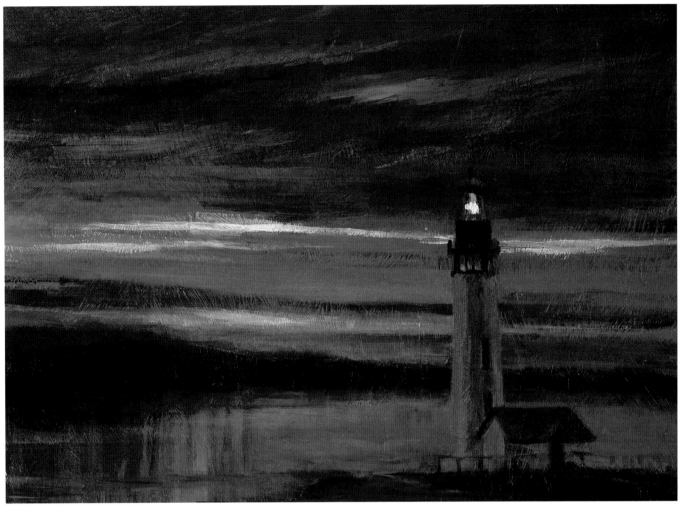

4. Finish

Mix Cadmium Orange with Cadmium Yellow Light and apply this mixture with a no. 16 bright to the horizon. Use more of the dark purple mixture to add finishing details on the lighthouse. Slightly darken the center of the lighthouse to imply roundness. Brush a tiny bit of the red mixture along the left side of the lighthouse and the left side of the second building to indicate reflected light. Drag this same mixture through water to break through the reflections.

Lighthouse at Sunrise, DYANNA SHYNE, Acrylic on watercolor board, 21" × 27" (53cm × 69cm)

Water

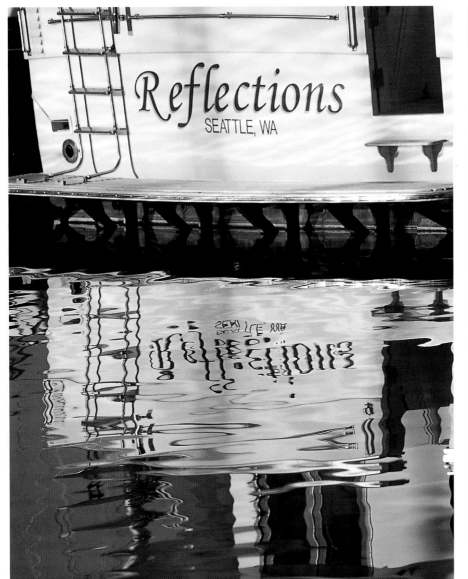

Clouds and Vistas

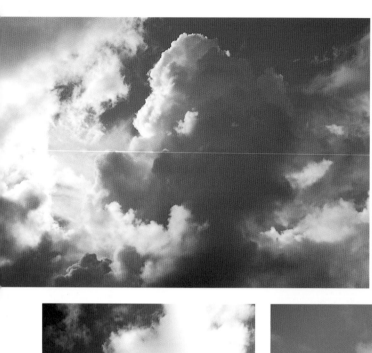

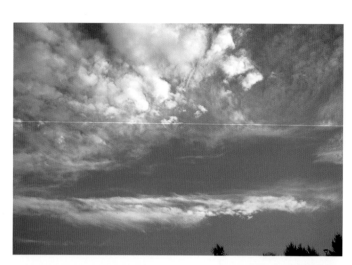

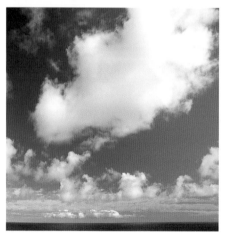

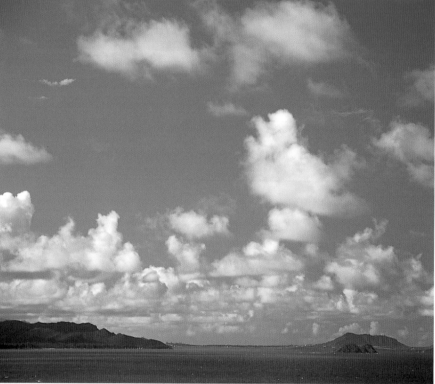

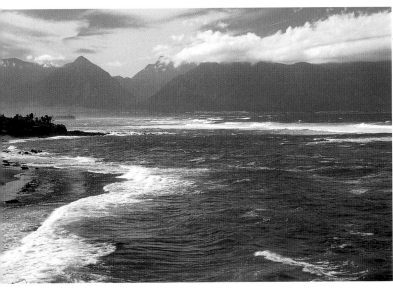
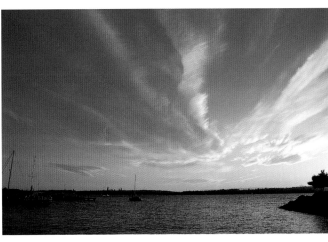
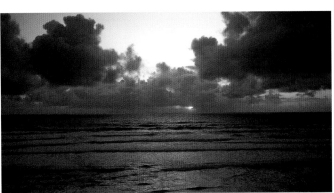
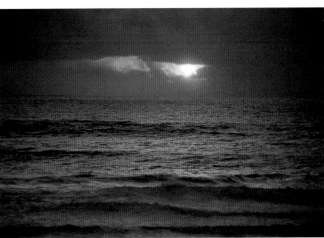
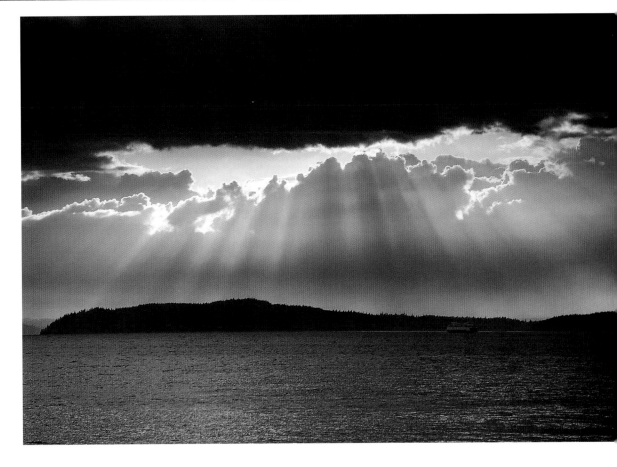

Sunsets

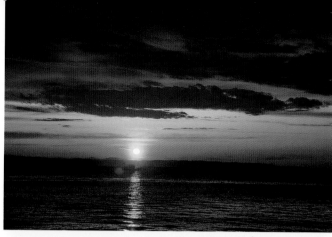

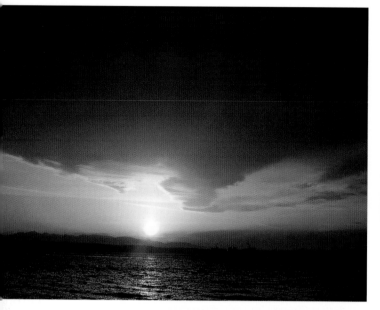

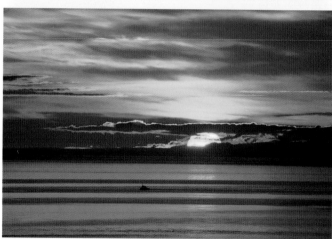

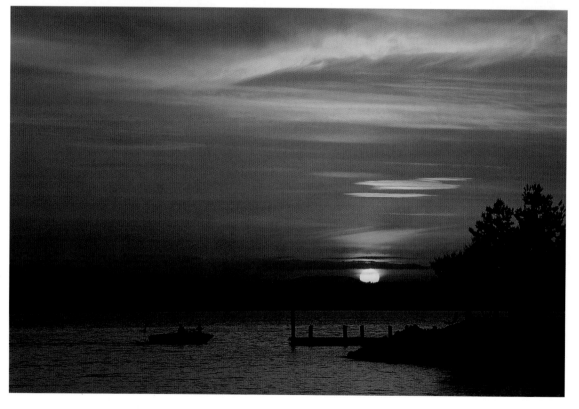

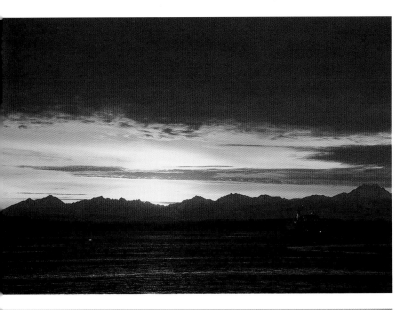

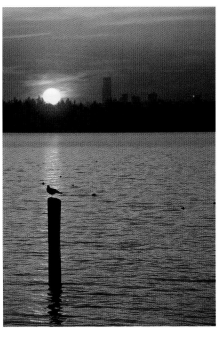

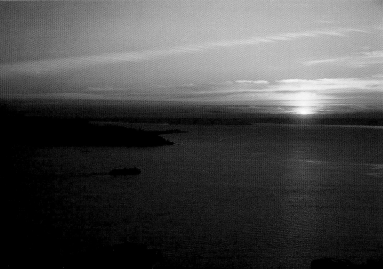

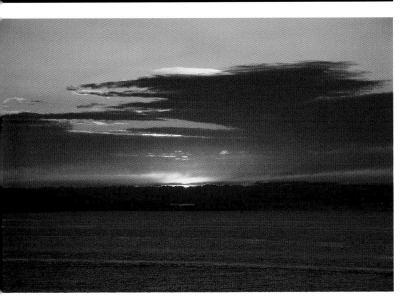

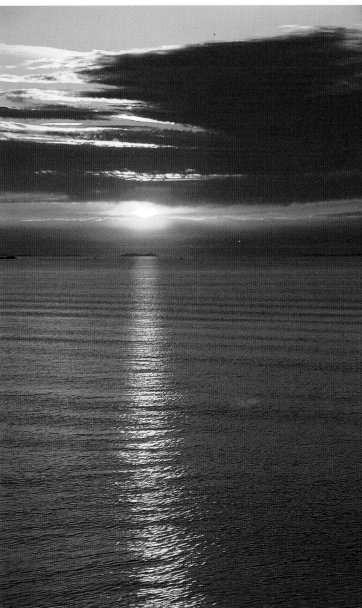

Contributing Artists

Norma Auer Adams

Norma Auer Adams graduated with a BA in Art from Stanford University and has worked with Doris White and Christopher Schink at Maine's prestigious Rangemark Master Class.

Her award-winning work has been featured in numerous museum exhibits and private collections as well as national and regional juried exhibitions. Of her many exhibition credits, she has shown at the Southern Alleghenies Museum of Art, the Springville Museum of Art and the Asheville Art Museum.

Norma's many awards include the San Diego Watercolor Society Purchase Award, the Greenville Artists Guild Award and the National Association to Women Artists Gehner Watercolor Award.

Jennifer Wood Bowman

Jennifer Wood Bowman is a Northwest watercolor artist who has exhibited professionally for the past 14 years. She has shown nationally as well as throughout the Puget Sound region where she lives and teaches.

Originally commissioned to paint portraits of local boats, Jennifer's work now has graced the cover of Seattle's *48 Degrees North* more than six times.

Currently, she is a member of both the Northwest Watercolor Society and the San Diego Watercolor Society. Among her many awards, she has received the Mayor's Purchase Award, the 200th Anniversary of Mt. Rainier Award and a Winsor & Newton Award.

Ross Nicoll

Ross Nicoll has been an artist most of his life. After serving an engineering apprenticeship, Ross became a technical illustrator 12 years ago.

Although Ross is mostly self-taught, he exhibits professionally in national and international venues. He is represented by the Kirkland gallery and has exhibited at the Seattle's Frye Art Museum. His work can be seen at galleries in nearby Bellevue, Renton, Bothell, Edmonds and Issaquah.

He continues to build on the knowledge he has acquired on his own, taking classes with Seattle artists Chuck Webster and Jess Cauthorn.

Ted Pankowski

After only a few years of painting experience, regional artist Ted Pankowski decided to transform his lifelong love of painting into a profession.

His commitment to painting has been a constant in his life. Although he admits he is a self-taught artist, Pankowski continues to attend workshops given by nationally renown painters such as Matt Smith and Ned Mueller.

His work has received wide recognition and numerous awards. He consistently shows at the Edmonds Arts Festival and the Bothell Fair. In addition to his success as a painter, Pankowski was invited to teach at the Arts Umbrella in Bothell, a 15-year-old community resource for aspiring new artists.

Dyanna Shyne

Dyanna Shyne, a native of the Pacific Northwest, has been painting for almost 20 years.

Dyanna's paintings have received over a dozen national awards including the Grumbacher Gold Medallion. Her work is included in private and corporate collections, as well as in the permanent collection of the Wiregrass Museum.

In 2001, Dyanna began teaching at the University of Washington Women's Center and became president of the Northwest Watercolor Society. Most recently, Dyanna gave a demonstration of her acrylic painting technique at the Seattle and Bellevue Art Museums.

Explore Your Art With North Light Books

Create your own artist's journal and capture those fleeting moments of inspiration and beauty! Erin O'Toole's friendly, fun-to-read advice makes getting started easy. You'll learn how to observe and record what you see, compose images that come alive with color and movement, and make a travel kit for creating art anywhere, at any time.

ISBN 1-58180-170-X, hardcover, 128 pages, #31921-K

Mastering basic brushwork is easy with Mark Christopher Weber's step-by-step instructions and big, detailed artwork. See each brushstroke up close, just as it appears on the canvas! You'll learn how to mix and load paint, shape your brush and apply a variety of intriguing strokes in seven easy-to-follow demonstrations.

ISBN 1-58180-168-8, hardcover, 144 pages, #31918-K

This lively, liberating guide will have you shedding your tight painting approaches in favor of what is called "Quick Studies." Craig Nelson's proven method of painting focuses on the essence of the subject and the mastery of the medium, rather than the minute details that seem to mire some artists and prevent them from improving.

ISBN 1-58180-196-3, hardcover, 144 pages, #31969-K

Many adults who decide to "study art" become too serious and frustrated, thinking they will never learn what it takes to be really good. Paint Happy encourages readers to relax and enjoy their work by combining expressive painting techniques with their own unique style. Cristina emphasizes self-expression without leaving out basic tools of composition and color.

ISBN 1-58180-118-1, paperback, 112 pages, #31814-K

These books and other fine North Light titles are available from your local art & craft retailer, bookstore, online supplier or by calling 1-800-448-0915.